THE WOMAN
WHO SAYS NO

MALTE HERWIG

Translation by JANE BILLINGHURST

THE WOMAN WHO SAYS NO

FRANÇOISE GILOT ON HER LIFE WITH AND WITHOUT PICASSO

REBEL · MUSE · ARTIST

GREYSTONE BOOKS

Vancouver/Berkeley

16 17 18 19 20 5 4 3 2 1

Greystone Books Ltd.
www.greystonebooks.com

Cataloguing data available from Library and Archives Canada
ISBN 978-1-77164-227-9 (cloth)
ISBN 978-1-77164-228-6 (epub)

Copyediting by Shirarose Wilensky
Jacket and text design by Peter Cocking
Jacket photograph courtesy Françoise Gilot, private archive
Printed and bound in China by 1010 Printing International Ltd.
Distributed in the U.S. by Publishers Group West

Photographs by Ana Lessing, except: pages 8-9, 16, 20, 141: Françoise Gilot,
private archive; page 26: Robert Capa © International Center of Photography/
Magnum Photos/Focus Agency; page 50: Rapho, Paris—Doisneau; page 106:
Francois Pages/Getty Images; pages 154-55: Bruno Mouron. The illustrations
on the endpapers at the front and back of the book and on pages 100-101 show
motifs from Françoise Gilot's Venetian travel sketches.

Reproduction of passages from Françoise Gilot's memoir, *Life with Picasso*, with
kind permission of McGraw-Hill, New York, USA.

Every attempt has been made to trace ownership of copyrighted material. Information
that will allow the publisher to rectify any credit or reference is welcome.

We gratefully acknowledge the financial support of the Canada Council for the Arts,
the British Columbia Arts Council, the Province of British Columbia through
the Book Publishing Tax Credit, and the Government of Canada through the
Canada Book Fund for our publishing activities.

Greystone Books is committed to reducing the consumption of old-growth
forests in the books it publishes. This book is one step toward that goal.

No matter how old you are, you must behave
like the ocean. Watch the movement of the
waves, the coming and going of the tides.
All life has movement, rhythm, a momentum
you must seize like a dancer, and if you allow
this movement to flow through you, then
you become one with the rhythm of life.

FRANÇOISE GILOT

CONTENTS

[1] **THE WOMAN WHO SAYS NO** *1*

[2] **NORTH LIGHT** *11*

[3] **FACES** *17*

[4] **CHILDREN'S GAMES** *21*

[5] **LIGHT AND SHADOW** *27*

[6] **DANCE** *33*

[7] **MATISSE** *43*

[8] **LA FEMME-FLEUR (WOMAN-FLOWER)** *51*

[9] **SHE AND I** *59*

[10] **FLY, BIRD** *69*

[11] **MISTAKES** *79*

[12] **CONTEMPLATING NOTHING** *87*

[13] **ABOUT THE PAINTINGS** *97*

[14] **SYLVETTE** *107*

[15] **TWO MUSES** *115*

[16] **COLOR AND FORM** *123*

[17] **LOVE** *131*

[18] **CHILDREN, COOKING, ART** *143*

NOTES *161*

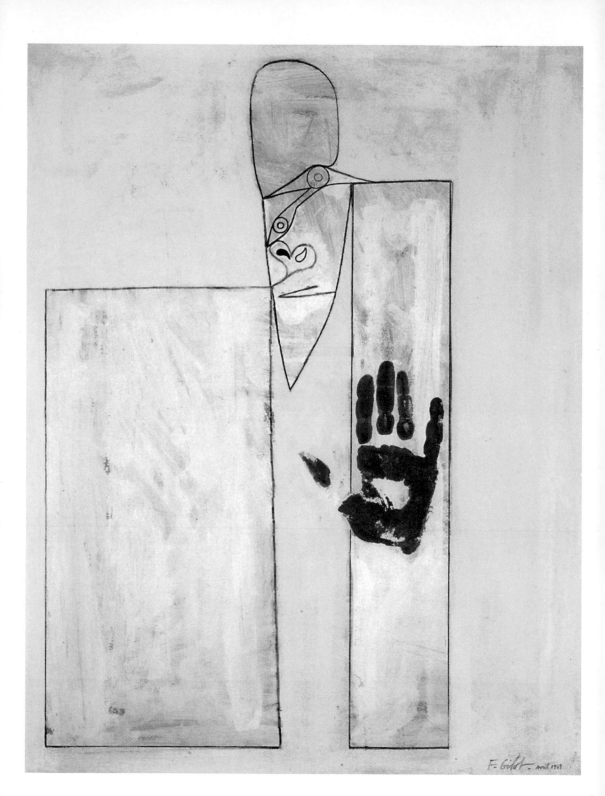

THE WOMAN WHO SAYS NO

PICASSO RAGED. Laden with suitcases, two children, and a young woman, the taxi sped off from the Villa La Galloise in Vallauris. Soon the car was nothing more than a cloud of dust stretching along the southern French country road in the direction of Paris. Picasso strode angrily back into the empty house. She had actually done it. She had kept her word, and she was gone for good with both the children—his children! This was outrageous, completely unforeseen, and completely unforeseeable in the old master's life plan.

The woman in the car did not look back, but she could readily imagine the state Picasso was in. For ten years they had been a couple—young Françoise and old Pablo. She knew him better than almost anyone else. She knew both his tender and his terrible sides. But she also knew that she and her children would be lost if they stayed with him any longer. Françoise looked at Claude and Paloma, who were sitting next to her. She still loved Pablo, but she loved the children more.

< *Don't Touch Me*, 1948, brush and
gouache on paper, 65.5 x 50 cm.

"No woman leaves a man like me," Pablo had explained to her just a few weeks earlier, all the while fixing her with his darkly luminous basilisk gaze. He was rich and famous, the best-known painter in the world, a king in the world of art—a god, even. In five hundred years, people would still be admiring his work and there would be books written about him. She, however, would be a mere footnote in the shadow of his genius. He considered himself to be irreplaceable and irresistible. If he was also sometimes insufferable, those who surrounded him graciously accepted this as the price they paid for the favor of his presence.

And what about her? She burst out laughing and countered that in that case she would be the first woman who ever succeeded in leaving him. He had always loved her bright, uninhibited laugh, but this time, it got on his nerves. This time, it struck fear into his heart. Leave him? What was there to laugh about in that? He was deadly serious. So, apparently, was she.

FROM NOW ON, she told him, she wanted to engage with people of her own generation and the issues they were grappling with—another statement that made him bristle with anger. Certainly, there was a forty-year age gap between them, but what did that matter? Surely the present always belonged to him, the eternal child? His creative works kept him younger and stronger than any of her contemporaries. And she had the gall to bring his age into the conversation? This was pure blasphemy.

He implored her, he berated her, he appealed to her sense of duty (she had to stay with him because of the children), and then he threatened her: "You imagine people will be interested in *you*? They won't ever, really, just for yourself. Even if you think people like you, it will only be a kind of curiosity they will have about a person whose life has touched mine so intimately. And you'll be left with only the taste of ashes in your mouth. For you reality is finished; it ends right here. If you attempt to take a step outside my reality—which has become yours, inasmuch as I found you when you were young and unformed and I burned everything around you—you're headed straight for the desert."[1]

It was meant as a warning but also as a curse: Without me you are nothing. I am the sun, the light, life itself. Without me you will dry up, little flower, you will disappear into the void. I painted you before you were even born!

I loved you because you needed my love, and you do not deserve to be loved if not by me.

But this time nothing worked. She said she would rather live in the desert than in his shadow. She wanted to find her "I" again was how she put it. As though there was anything so horribly sentimental as happiness in this world. What modern nonsense women like her believed! Where were Roman mothers today—an expression he loved to use—women who happily sacrificed themselves for their husbands and children?

Françoise smiled. Even a genius can believe such naïve nonsense. But she knew that Picasso's rant wasn't so much to make her change her mind as it was to cover up his own anger about being left alone. The young woman caught herself almost feeling sorry for the tyrannical genius whom she had, indeed, left forever. She imagined the great Picasso sitting stunned and alone. She imagined him looking around the house where they had lived for the past five years, the house that he had filled with ceramics in bouts of restless productivity, a house that would now appear empty without her.

He looked around at the paintbrushes, bottles, and objects piled up on the floor and on shelves, and suddenly he was overcome by a feeling he had never experienced before. The unholy chaos that usually energized him in his work now only served to irritate him. Where was the calming counterweight to his crazy life? The admiring, adoring audience for his immense ego?

"Shit!"

Thoroughly miserable, Picasso sat down at the kitchen table and lit a cigarette. He should write to Sabartés, his trusty secretary in Paris, and ask him to check up on her. Perhaps she had a lover. Affairs had never meant much to him. There were times, of course, when he had to coax things along. There were women who dolled themselves up and pretended they wanted only to be painted by him. That in itself was enough to immortalize them in their own lifetimes. The rest was, as far as he was concerned, a question of gratitude, a mere formality, a postscript for his pleasure. They had never meant anything to him, and if they had, then only for a short time, after which he knew how to divest himself of them.

Once at the beginning of his career, when he was looking for an entry into better circles, he had made the grave mistake of marrying a woman. But Olga had already become a burden to him when he noticed Marie-Thérèse

and got her pregnant. Then along came Dora, and for a long time he amused himself by playing the two women against each other.

He always knew how to keep the less unimportant women in his life financially dependent so that they remained of service to him. In public he liked to pretend they meant nothing to him any longer and the mere fact of their existence was a burden to him. "Every time I change wives," he liked to complain, "I should burn the last one. That way I'd be rid of them." In reality, however, his boasting was merely a cover. The idea that one of his much-younger women could outlive him made him furious, and he, never one to dismiss superstition, believed the death of another might win him back his youth. Even if he shrank from explicitly expressing this awful idea, he had the habit of promising his lovers that, somehow, he would outlive them. He had threatened Françoise as well: "You will not live as long as I will." But she had only laughed and countered: "We'll see about that." People just did not talk to him like that. What was she thinking? It was not for nothing that he called her "The Woman Who Says No." But that had been meant as a harmless joke.

And now she had made good on her threat and abandoned him. Nothing like that had ever happened to him before. For a fraction of a second, Picasso's heart made room for the thought that perhaps it had been a mistake, after all, to think only of himself and to assume other people would patiently accept his escapades. He slapped the idea away as though it were a pesky bug and returned to his natural state of righteous anger.

What did it matter that he had not always been faithful to her? Art was the only thing he had to be faithful to and the only thing he felt accountable to. He offered everything up to art, when necessary even those nearest and dearest to him, even himself. She had known that from the beginning. And through her calm acceptance of his extravagances, his affairs, and his fits of rage, she had indicated that she accepted him as he was. She had gone so far as to take on the role of mother, even if she had done so only after considerable hesitation and only at his insistence. He finally demanded that she bear him children, because he wanted to bind her to him completely. First she presented him with Claude, and then with Paloma, and he had painted mother, son, and daughter over and over again.

The idea that another man would now take his place was impossible for him to bear. It made him beside himself with rage. He was the master; she

was his muse. He had discovered her when she was twenty-one years old, young and unaffected, as chaste as a white canvas waiting for him to fill it with color.

He felt it would not be going too far to say that her life first started when she met him. He created her. In the ten years they had loved one another he had molded her like a ceramic sculpture into the person she was today. In his hands she had been tempered by fire. He liked to say that he had branded her with his tumultuous spirit and she would forever bear its mark. He loved such expressions, because they helped him corral the chaos of the world, and they reminded him of his childhood in Spain. He was only nine years old when his father first took him to a bullfight. Bulls and matadors, each with their roles to play in a struggle with clear-cut rules. His first oil painting back in 1891.

She was his creation, so he got to say what would happen to her. No one would dare, or even be in the position, to change a single line of his work of art or add a single stroke.

This thought calmed him a little. Even if he no longer possessed her, at least no one else would either. Even a man who was prepared to give himself over to her completely would not be capable of helping her. Whatever she did from now on would play out in front of a mirror that would reflect back to her everything she had experienced with him.

Still, he felt fate had dealt him a low blow when she left him this morning. He shuffled sullenly into the bathroom and looked at his face in the mirror. When a few minutes of contemplating his reflection did nothing to improve his mood, he grabbed his razor and brush and began to shave. He hated stubble. Sometimes he shaved as often as three times a day so that his skin always felt as smooth as that of an innocent baby. The ritual soothed him. When he was finished, he dipped his index finger into the shaving foam. He painted thick lips like a clown on his face, and under each eye he drew a tear. It didn't help. With a forced smile, he accepted he was still alone, a deserted, sad harlequin with no one to witness his performance but himself.

The rage that had engulfed him when she left had ebbed slightly, and he was now overcome by a wave of self-pity. Did she have absolutely no appreciation for his situation? Who would he have to talk to now about all the

5

things that were troubling him? He had way too many things to do to be alone right now. It was irresponsible of her to simply leave him on his own like this.

Yet he had to admit that Françoise's flight, for that was what it was, was not unexpected. He knew she had been unhappy, but he had ignored the signs and been stricter with her than ever. One time when she was crying yet again—which was unlike her, as she was usually so controlled—he drew her and praised the sincerity of her grief. "Your face is wonderful today." Another time he scolded her, because she had lost weight after the birth of her second child. "You used to look like a Venus. Now you look like Christ on the cross, with your ribs sticking out so far you can count them." She should be ashamed of herself. Every other woman looked more beautiful after the birth of a child, but she looked like a broomstick.

If he woke up depressed, as he did most days, she refused to cheer him up and admitted he was right when he complained once again about how bad life was. She even encouraged him in his complaints—everything really was awful, and tomorrow things would be even worse—until he became violently angry and threatened to take his own life. He kept her up nights talking, often until the early hours of the morning, lecturing her and moaning about life until she was so tired she passed out from exhaustion. Then he was happy, because he saw that even though she was only thirty-two years old, she did not share his robust constitution.

HE OFTEN VERBALLY abused her until she was completely eviscerated, and then he talked his way out of it by saying it was all just a game: "I'm always saying things I don't mean. You should know that. When I shout at you and say disagreeable things, it's to toughen you up. I'd like *you* to get angry, shout, and carry on, but you don't. You go silent on me, become sarcastic, a little bitter, aloof, and cold. I'd like just once to see you spill your guts out on the table, laugh, cry—play *my* game."[2] But she had refused to give in, and that only served to fuel his hostility.

When she cried, he always knew he had hit his mark. But even though his rapier-sharp remarks had easily pierced so many hearts, mostly he found it incredibly difficult to penetrate her armor. She was as tough and impervious as the lobsters and knights that increasingly populated his paintings.

But he persisted with the game and painted her in a green dress on a blood-red floor, wrestling with a large dog. That was in February, a few months before her eventual departure, and he already suspected she wanted to leave him. As though to reassure himself, he told everyone: "You must know, Françoise is going to leave me!" Of course, he hadn't thought it would ever really come to that. His confidence in himself and his ability to steer things his way were simply too strong for her to succeed.

In the weeks and months that followed, when Françoise made no move to return to him, Picasso took the steps required to put the correct slant on the story. He was a master at what is now called crisis management. He wrote to his secretary, Sabartés, and spread the news among his friends. Soon the whole of Vallauris was lamenting that the master had been abandoned—and at his age!

From Vallauris, the news spread as it was eagerly regurgitated by journalists: Picasso's young companion had left the master because she no longer wished to live with "a historical monument." She had never said that; it was Picasso himself who orchestrated what people should think.

No one suspected how deeply he was affected by having been left. She had won because she had survived. The bull had fled the ring and left the baffled matador standing in the dust with his cape and dagger. The game was over, and this time the most famous artist in the world had not won.

Christmas 1953 was a lonely celebration for Picasso. On December 29, he stepped up to the easel and painted Françoise one last time. She is lying on the blue bed in their shared bedroom, her arms flung back over her head, her skin a gleaming white. But through the doorway the long shadow of a man falls over her naked body, and he is this man. She had withdrawn from him, and only his shadow could still touch her.

Was he overcome by pain, longing, or grief? He did what he had always done in such situations: he poured his innermost emotions onto the blank canvas to exorcize them. She had escaped from his light, but she would always be in his shadow.

Or so he thought.

Françoise Gilot at a bullfight in
Vallauris in 1954 (newspaper cutting).

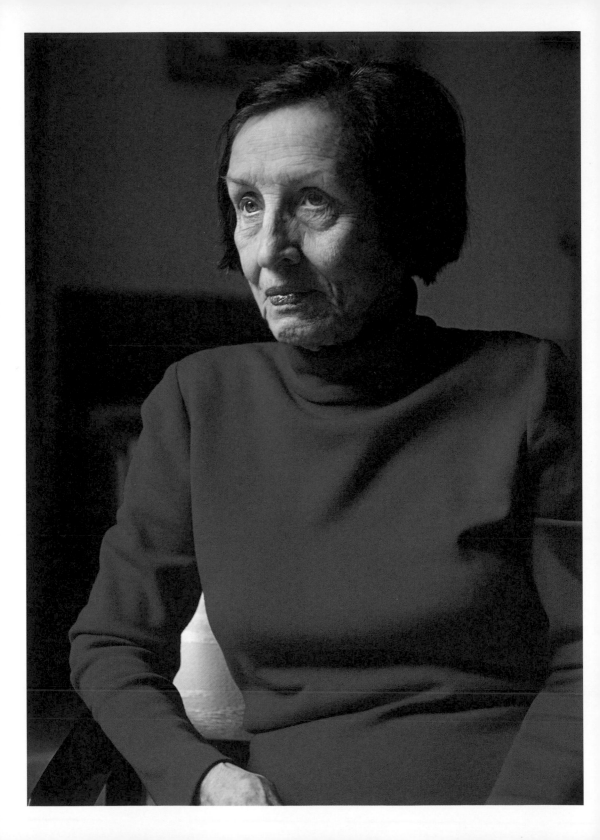

"Personally I always allow my reason to
serve my folly rather than the opposite."

FRANÇOISE GILOT, *Monograph 1940-2000*

PARIS

NORTH LIGHT

IT WAS 2012 when I met her for the first time. It was in Paris, in May. Sidewalk artists were sketching Japanese tourists in the Place du Tertre in Montmartre. Not much was left of the famous atmosphere of the quarter where once Renoir and van Gogh lived and Picasso had his studio.

But I had heard that this was still a lively place if you knew where to look. A few streets farther over, one of the most famous survivors of art history was working in an atelier flooded with light. I rang at the door of the old building and was let in. She stood before me: a small red dress, a short pageboy haircut, the legendary circumflex eyebrows—which Henri Matisse had once raved about—dancing up and down over lively eyes. The painter Françoise Gilot. She was ninety then and seemed to me to be no more than half that age. She leapt up, laughed, and walked around. In proportion to her diminutive frame, her hands are powerful, I thought. Painting is work, and she was still painting every day.

"When you paint, you have to be quick. Even if it is not turning out very well, it is always better than going slowly. You must bring the energy of your entire existence into the picture." In front of her stood two heavy easels with large abstract paintings on blue backgrounds. They were still there even though they were finished, fresh showpieces for visitors. "I would never show people works in progress."

On the left-hand side there was a simple white table, cans full of brushes, pasta-sauce jars filled with thinners, tools of the artistic alchemist. Leaning up against the walls were dozens of portfolios in large and small formats, full of pictures and drawings—all with their backs to the visitor. I noticed right away: this is no museum, no gallery; this is a workshop.

She always begins her work at dawn, still in her pajamas and slippers. One glance from the loft to the half-finished canvas on the easel, and then the artist descends and immediately sets to work. That is the way it has been for seventy-five years.

I looked around: not a stool in sight. Françoise Gilot paints standing up, hence the slippers. They are more comfortable when you are standing for hours at a time. I tried to picture this elegant, dainty woman lurking in front of the easel in her paint-spattered pajamas and slippers, armed with a paintbrush in each hand—impossible.

She laughed. "When you are wearing your nightclothes, you are not so critical. Sometimes the critic in me perches on my shoulder like a bird. But reason is no friend to the artist. You don't necessarily need it when you work. To paint, you need passion. You must get into the rhythm and chase the bird of doubt from your shoulder."

Age is not a friend to the artist, either. Five years earlier, she had voluntarily given up driving—problems with her heart. Not that she was afraid of death, but she didn't want to take anyone with her. "If you have a heart attack on the freeway, you'll probably kill someone else." Another age-related affliction weighed more heavily. She was by then almost blind in her left eye. A catastrophe for an artist—or was it? "Nonsense. That doesn't bother me at all. Of course, it could be a problem when painting perspectives, but in my paintings I create space not with perspective but with color."

Her relaxed attitude surprised me. How often had I heard old people complain about this and that, which is completely understandable with

the diminishing energy and increasing physical discomfort of advancing age. Françoise Gilot doesn't seem to let this affect her; she just keeps going. Moreover, she seems to be amazed by her own resilience.

"Basically, I'm done with life," she said, throwing her hands up in the air in exasperation. Had she not already done and experienced everything? What was she still doing here?

"When I was eighty-six I thought, this is finally the end, because this is the age my mother died. I couldn't imagine living longer than she did, because until then, no one in our family had lived longer than she had. Then I got to be eighty-seven, and I was amazed. Eighty-eight was madness. Eighty-nine seemed impossible, and ninety was really the last straw. When I turned ninety, I thought, you are going to have to take your own life if you ever want to die. But because I saw no reason to take my own life, I continue to live, and I tell myself, 'You just have to endure this.' I hate it. But as I'm still here, I keep on painting."

FOR A NINETY-YEAR-OLD who is tired of life, Françoise Gilot certainly has quite a lot to do. Ten months of the year she lives and works in her one-hundred-year-old studio just a few meters away from Central Park on the Upper West Side of Manhattan. She spends May and June in Paris, in her second studio, which is just as large as the one in New York. The pictures travel back and forth with her.

When I remarked that despite a surfeit of life she had more energy than a handful of teenagers, she gave me a sharp look. "I said I was tired of life, not tired of painting!"

Seventy-five years have given rise to an impressive body of work: more than 5,000 drawings and 1,600 paintings to date, and the collection is growing daily. "I don't do anything other than paint." That's an understatement. There are the archives in which her most important works are recorded with meticulous detail and which need to be attended to. There is correspondence from around the world that does not let up. There is no country from which she receives more mail than from Germany. "Every month I get three or four letters from Germany asking for my autograph. Isn't that funny?"

Only the smallest portion of her pictures is on display in museums, yet she is everywhere. For more than a half century, she has had at least one exhibition

of her work every year. In 2003 and 2011, the Chemnitz art collection in Germany mounted exhibitions dedicated to her art. Most of her paintings are in private collections in America, England, Scandinavia, and Germany.

The Metropolitan Museum of Art in New York has purchased some drawings, including an early self-portrait from 1941 in which the twenty-year-old Françoise Gilot looks directly at the viewer with a stern gaze. By then, Paris was under German occupation, and the life of the young student of philosophy and law had been in danger more than once.

ON NOVEMBER 11, 1940, Françoise Gilot marched with her fellow students to the Arc de Triomphe to lay flowers on the grave of the unknown soldier. She was arrested and her name was added to a list of hostages: if a German soldier were to be killed in her neighborhood, the Germans would kill fifty French citizens on that list. "It was rather unpleasant," she remembered. For three months, she had to check in at the commandant's office.

But the wide eyes of the young woman in the self-portrait from 1941 are not the terrified eyes of an animal caught in the headlights. They express not fear but curiosity about, and even lust for, life. Her gaze is serious and strong. In her world view, there is no misfortune that does not also have its positive side.

Although her parents recognized and encouraged the artistic talent of their only daughter early in her life, her father forbade her to attend art school and make painting her career. So after her official studies, she added a secret assignation—a weekly visit to the Hungarian painter Endre Rozsda.

Three months after her arrest, she had an audacious idea. When the time came for her to check in at the German commandant's office once again, she reported she was no longer studying law. "For some reason, the Germans hated law students. So I said, 'I am a fashion designer.' Then they let me go, and since then I've painted every day."

Françoise Gilot painted her first oil in 1939, when she was seventeen years old. It depicts the view out of a window onto a sun-drenched French landscape. You can see immediately that the painting encapsulates the story of her life. The large open doors are painted cool blue, and the filigree ironwork of the French balcony creates a certain distance between the interior of the room and the wildly colorful world outside.

Françoise Gilot has never turned her back on her cool Nordic temperament, inherited from a branch of her family that settled in Normandy and Alsace. "For the Italians it's all about style and expression. The Spanish search for extremes, for brutal deformity. I think that in my painting I am more of a mathematician or a philosopher, and so I am more typically French. People in the north of France have a particular interest in combining mathematics and metaphysics. My ancestors come from Viking stock, so is it any wonder that my pictures are northern pictures?"

North is her cardinal direction. And it is the direction from which the light must come as it falls softly through the six-meter-high window onto the Art Deco furniture in her Paris studio. "North light is the best because it is the same intensity all day long." These are the cardinal points of the painter's compass: east is second best, south is not so good, and the very worst is west, with its sultry afternoon light that bathes the canvas in a gaudy pink. "Once I had a studio with thirty-six windows, and not one of them faced north!" Naturally, both of the studios she has now—the one in New York and the one in Paris—face north.

Françoise Gilot was never one to open up to others, not even to her own family. Was her heritage too Nordic, too French, too genteel for her to show her emotions? *Quelle horreur!* "Despite our ten years together, even Picasso never knew me, because I shut myself away. I never reveal myself. Why should I?" she said in the politest of tones, and then broke the spell with a peal of laughter.

Wasn't it hard, I wondered, to experience so much and then keep her true feelings bottled up like a message adrift on the sea? "Not at all, because I express myself through my paintings, and even then they are still mysterious. When I paint, all my feelings are in there, but not everyone can decipher them."

When I said goodbye to Françoise Gilot the evening of our first meeting and descended Montmartre, I knew I had to see her again.

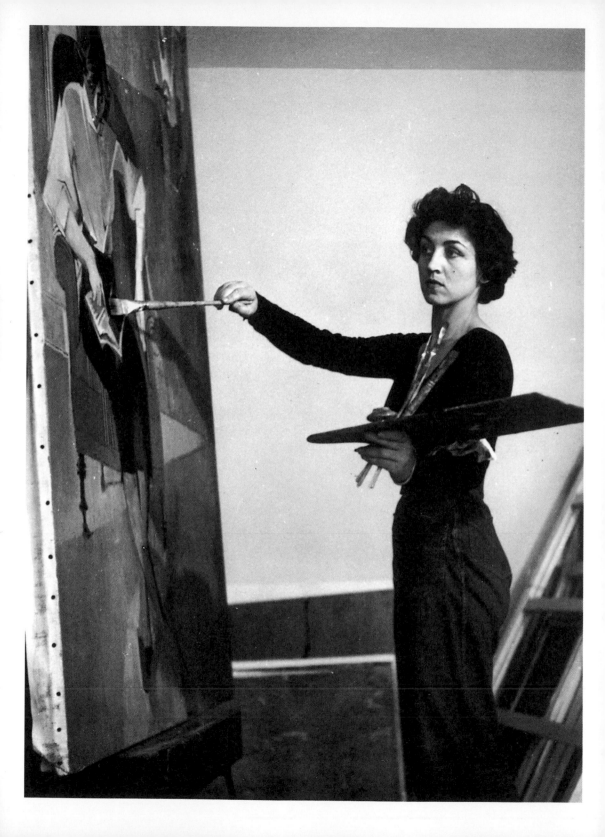

"My eyes were born first. They saw their cage. Vertical lines of saffron yellow, indigo blue, saffron yellow, indigo blue... one color, then the other, then the first again. Always this alternation of verticals, yellows and blues, bars of gold in the night or bars of darkness in the sun. Where am I locked up? Am I deprived of my soft, dark velvet? Am I a prisoner in this dazzling cage? Why am I kept away from the sun's heat, held back by the dull links of an iron cage?"

FRANÇOISE GILOT, *Interface: The Painter and the Mask*

ANTWERP, SUMMER 1926

FACES

ONE OF HER first memories: In 1926, five-year-old Françoise and her father were walking through the Antwerp zoo. She was holding her father's hand and staring wide eyed at the animals behind the bars. She was particularly drawn to the wolves. Then they stopped in front of the ape enclosure.

Emile Gilot had always wanted a son, and the successful chemical manufacturer usually got his way. When his wife bore him a daughter, he decided simply to ignore the gender of the child and bring her up as though she were a boy.

Perhaps her father just wanted to entertain himself and the public; perhaps following his blueprint for his child's upbringing, he just wanted to toughen her up so that she could face life's challenges. Whatever the reason, he pushed the resisting child into the ape's cage and ordered the zoo attendant to shut the door.

< At work (Paris, 1955).

The startled five-year-old looked around the cage. With perfect manners, the chimpanzee extended his leathery paw in greeting and led her around his quarters. Then he sat down at a small table with her, holding her hand in his as though this were a formal rendezvous, and observed her with an expression that alternated between amazement and amusement.

The crowd outside the cage guffawed. The girl looked at the people through the bars with a mixture of anxiety and fascination. The roaring mass of faces with wide-open mouths looked to her like a surging carnival in the middle of which she and her apish gallant were objects of amusement.

She became furious. What monsters people were, locking their animal relatives in cages to dominate and ridicule them. It would never occur to anyone to make fun of an ape swinging with grace and power through the forest. Only in captivity did they become ludicrous. The longer she sat there, the more alien the crowd out there appeared to her, and soon it seemed to the little girl as though it was the people who were caged, trapped behind the bars of their own world. She held the ape's hand more tightly. He was her partner in the face of derision, and she was his comrade in misery.

Half an eternity passed before the door to the cage opened again and a laughing Emile Gilot welcomed her back into the world of people, his world. Her father didn't notice that the five-year-old's outlook on life had been changed forever. She had suddenly aged by much more than the time she had spent in the cage, and never again would she put her trust in external appearances. Instead, from now on, whenever she began to paint, she was on the trail of the truth that lay behind the visible world.

The Painter, 1948,
mixed media on paper, 65 x 50 cm. >

Mars 1948

F. Gilot

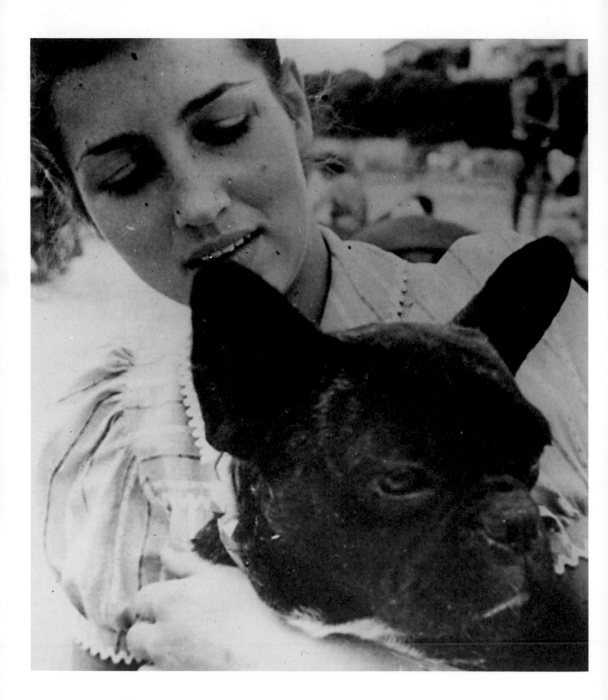

At fifteen.

"Since childhood I have searched for ways to seduce painting, to ensnare painting. My eye has measured and compared; at times my gaze was fearful, at others bold. What was not solved consciously was often resolved in sleep through dreams. I had to be brave before the Gorgon-faced painting of others, to decipher riddles, to rework experiences, to study approaches, to play the game, to take on roles and even follow them along the thread of time in keeping with my own development, or to reject them and venture defenseless into the unknown. The gaze scans future and past, past and future, back and forth, *gradually becoming what it creates.*"

FRANÇOISE GILOT, *Interface: The Painter and the Mask*

NEUILLY-SUR-SEINE, 1927

CHILDREN'S GAMES

FRANÇOISE WAS BORN on November 26, 1921, shortly after midnight. Her parents' house stood in Neuilly-sur-Seine, a tony Paris suburb. Her parents were rich; her grandparents were even richer. After the early death of her husband, Marie-Florence Gilot, her paternal grandmother, had purchased a perfume factory and earned herself a fortune. Françoise's father, Emile, later worked in the factory.

Financial independence allowed Emile to follow his passion for literature and to amass an impressive personal library. Her father was firmly convinced that children's capacity for learning in their early years was almost limitless. Françoise was left-handed, but to prove his theory, he forced her to learn to write with her right hand before she even turned four.

She was a bright child and delighted her father, who gave her books to read on nights when she couldn't sleep. By the time she was six, she had

already read her way through the Greek myths. By the time she was twelve, she knew Baudelaire, Poe, and Rabelais.

She was different from other children her age. Her favorite color was gray. When she was sent to a public school after five years of study at home, the lessons soon bored her. She whiled away the hours in class by filling her school notebooks with abstract color mandalas, until her mother, who was a gifted artist, agreed to teach her how to draw from nature.

THE NIGHT OF January 1, 1927, Françoise observed a special guest at her grandmother's New Year's Day reception. The man with the broad-brimmed hat and black eyes handed the hostess an overly large bouquet of purple violets. He looked as though he had just stepped out of an Impressionist painting. When the five-year-old learned he was the painter Emile Mairet, she vowed before the assembled guests that she would become a painter herself.

Painting is first and foremost a handicraft. It requires manual dexterity, knowledge of tools, and an understanding of how colors work together. Her father was a passionate admirer of Mairet, and soon he took her with him to Mairet's studio in the Jardin du Luxembourg, where, for the first time, she got a glimpse of an artist's workshop. At home, her mother instructed her how to paint with ink and watercolors. Madeleine Gilot was a strict teacher. She dismissed pencil drawing as an exercise for beginners, because mistakes could be so easily corrected with an eraser.

You must learn from your mistakes instead of wiping them away. A false stroke or color applied too thickly must become part of a new composition, until everything fits together. Françoise has remained true to this philosophy to this day, not only in her painting but also in her life. Whatever has been experienced remains and cannot be washed away. It is forever a part of you, but what counts in the end is what you make of everything—life as artistic synthesis.

It is not technique that separates the artist from the craftsperson. A forger might paint a picture better than the artist herself, but the forger remains forever a slave to someone else's genius, and the painting remains the painting of the artist who originally created it.

The eye is the artist's most important tool, and her eyes were born first, as Françoise writes in her book *Interface: The Painter and the Mask.* Françoise's eyes are not eyes that simply look around but little demons that penetrate the visible world like X-rays in search of the rhythms that lie beneath the structure of physical objects.

The realm of childhood is a colorful chaos of stories, dreams, and ghosts that do not survive in the adult world. Little Françoise had a particular fondness for an alternate reality peopled by devils and phantoms. She painted goblins and demons until she became frightened of her own creations and hid them away in cardboard boxes she fashioned herself. Soon she had built a whole castle full of phantoms, owls, and bats that she could conjure up at will. The door into the other world was made of paper, which made it easily accessible.

Yet disillusionment soon followed. The forms she had created were born of her imagination. They were nothing but lifeless drawings with no reality or life of their own. They did not play along.

What was the point, the child artist asked herself, of painting things that do not exist? It was self-deception, a complete waste of time. You must improve your ability to see; you must look more closely to grasp the essence of objects. Then painting will be worthwhile. Begin with yourself.

One day, Madeleine Gilot surprised her daughter as she was standing in her bedroom in front of a large mirror gazing at her own reflection. Her mother interpreted this childish curiosity as evidence of vanity—not a virtue that was particularly valued in upper-class circles—and she resorted to a ruse to rid the child of this would-be vice. "If you look in the mirror for too long, you will see the Devil."

Madeleine Gilot should have known her child better than that. The warning about the Devil not only failed to frighten her; it piqued the child's curiosity. As soon as her mother had closed the door behind her, Françoise stepped in front of the old mirror with its shiny greenish cast and looked for the Devil.

Then, all at once, it happened.

"For the first time, perhaps, I looked at my downcast reflection in the mirror as an object for study. I went to get crayons and paper and set to work. I

Children's Games

struggled for a while with proportions, the spacing, and the lines until, identifying with my work, I stopped analyzing, absorbed in the rhythm of the drawing. And then I was engulfed by a wave of emotions strong enough to cross an ocean. *I was carried along, determination took hold of me; I knew where the eyes, the nose, the mouth went. I marked their locations, I named them, I placed them, I shifted them. I ordered a face to appear on the paper, and suddenly, there it was!"* [1]

IN THAT MOMENT, something happened to her over which she had no control. When it seemed as though she wouldn't manage to get the proportions right, she was gripped by a strange sensation that guided her hand until she got the shapes on paper. And there, all of a sudden, was her own face, and it was no longer a distorted reflection but her true likeness.

She was so happy and excited that she had to share her incredible discovery right away. No one would understand her better than her maternal grandmother, whom she loved more than anyone else. Anne Renoult lived not far away from the Gilots' house. Françoise ran over and handed her self-portrait to her grandmother, breathless and proud. Anne Renoult was a long-suffering woman who had lost three of her five children and always wore black and white. Despite her misfortunes, she was endowed with a lively and happy disposition. She was tiny but feisty, and her granddaughter knew she could trust her with anything.

Anne gave the little girl a kiss and thanked her politely for her present. Then she began to laugh so hard that tears ran down her cheeks. "But darling, this isn't you at all. Fortunately, you are not as ugly as this. You don't have ears like cabbage leaves or a flat nose. You don't squint very often and your eyes aren't this awful color of stale oysters." [2]

While her grandmother continued with her critique, between chuckles and snorts of laughter, a lump rose in the young girl's throat and she had to force herself not to break into tears right away. How could her beloved grandmother, of all people, misunderstand her so? She couldn't tell her how much the picture meant to her, because that would hurt the old woman. Over the next decades, no art critic could deliver a more cutting judgment of the artist than her grandmother had done the day she wrote off the result of the

magical experience that had facilitated an authentic artistic breakthrough as the inept scribblings of a child.

Despondent, she made her way back to her parents' house. If her grandmother, who cared for her so much, could not understand what had just happened to her, then no one would.

"How did she know whether I was ugly or beautiful, since I didn't know it myself? Such distinctions did not concern me. I knew more about running than my knees did. My memory knew what odors my nostrils channeled upward, and my ears, open like cabbage leaves, were alert to the slightest sound. I knew that my drawing marked my first alliance with truth."[3]

She was alone, but she had found her way, and the picture was the beginning. "I am the painter. I am the jester who juggles time and space. Place your bets. Listen to me. Come on, place your bets, I tell you! Follow me into the painting."[4]

CÔTE D'AZUR, 1948

LIGHT AND SHADOW

WHEN I WAS a teenager, I collected photo portraits of Picasso. Whether he was dancing across his studio naked from the waist up, playing the part of a matador with a hand towel, or simply pulling silly faces while he posed with masks or animals or costumes, Picasso seemed to bask in an aura of magical creativity in even the most ridiculous situations. His childish frivolity, his levity, his games in front of and with the camera draw the viewer into the photograph, and it feels as though a spark of Picasso's energy makes the leap to his audience.

The most famous artist of his time, and perhaps of all time, was an exceptionally talented self-promoter. In 2011, when the Ludwig Museum in Cologne, Germany, mounted the first large exhibition of his photo portraits, the title tellingly ran *Ichundichundich* (MemyselfandI). There wasn't much room in Picasso's life for anything but himself and his art. The tyranny of genius reduced everyone else to playing bit parts in the drama of his life.

< With Pablo Picasso and his nephew Javier Vilato at the beach at Golfe-Juan (Côte d'Azur, 1948).

27

One picture, however, stood out. It delighted me so much at the time that I had it printed on a T-shirt. I could not get enough of this unknown young woman's smile as she walked along the beach, beaming as Picasso held a parasol over her to shield her from the sun. It was more than half a century ago: a hot summer's day in 1948, in the small resort town of Golfe-Juan on the Côte d'Azur in France, and the cool shade felt good.

It was a picture of pure vitality: light and laughter on their faces, Françoise Gilot in front, in the background Picasso's nephew Javier Vilato. Only Picasso, the old puppeteer, looks directly into the camera with his dark eyes and gives an ambiguous grin: I am the sun and the darkness; I am the center of the universe. Me, me, me.

To a certain extent it makes perfect sense that the cunning genius grabbed the parasol when the photographer Robert Capa wanted to photograph him and his entourage on the beach. Picasso would be the one to dictate where light and shadow would fall. And, of course, it was always the others who should stand in his shadow, in a world he created with his brush—or even with a sun umbrella.

But not this time. This time it was different. No hint of shadow falls on the face of the young woman. She is beaming—and she merely laughs him off. There are few women who came as close to the sun as Françoise Gilot. Most burned themselves up on the genius, overheating and crashing like Icarus in the ancient story. Françoise Gilot is the only woman who left Picasso instead of being discarded by him.

YEARS AGO, WHEN I heard her story, I was surprised to learn she was still alive. After all, her break with Picasso had happened over a half century ago, and the two of them had met way back during the Second World War. But when we spoke on the telephone for the first time to set up a magazine interview, I got the impression I was speaking with a woman who couldn't be more than fifty.

What surprised me even more was that she had survived him. This was not the natural order of things. Jacqueline Roque, Picasso's last wife, put an end to her life with a revolver thirteen years after his death. Marie-Thérèse Walter hanged herself. Olga Khokhlova and Dora Maar eventually went mad.

The man whose enormous creative drive filled museums and galleries like no other artist in the twentieth century left an unprecedented wake of destruction in his personal life. Picasso seemed to positively enjoy first imposing his will on the women in his circle to form them as though they were works of art, and then using every trick in the book to destroy them utterly. "He had a kind of Bluebeard complex," I read in Françoise Gilot's book *Life with Picasso*, "that made him want to cut the heads off all the women he had collected in his little private museum. But he did not cut the heads entirely off. He preferred to have life go on and to have all those women who had shared his life at one moment or another still letting out little peeps and cries of joy or pain and making a few gestures like disjointed dolls, just to prove that there was some life left in them, that it hung by a thread, and that he held the other end of the thread."

Picasso the puppeteer. That fit with the image of the confident, egomaniacal artist. But who was this woman whose beaming smile I had known for so long without even knowing her name, and what on earth had happened to her? How had she managed to find her way out of the Minotaur's labyrinth after living with him for ten long years?

Françoise Gilot's story reads like a fairy tale, but it is true. It's a story about the adventures of a woman who lived among monsters and gods but refused all her life to be devoured or beatified. Whether as artist, writer, philosopher, or mother, she remained true to herself, which endowed her with an amazing capacity to engage with life. In a way that is so different from the saber-rattling aggression of men, she emerged from the story victorious. It is no accident that her favorite animal is the horse, not the bull.

There is a Chinese proverb that says, "The great man is a public misfortune. His compatriots look like midgets and they often shiver in his shadow." Picasso knew this about himself: "Every positive value has its price in negative terms, and you never see anything very great which is not, at the same time, horrible in some respect. The genius of Einstein leads to Hiroshima."[1]

So he didn't even try to reduce the fatal side effects his existence had on others, and he lived ruthlessly, according to the maxim that no artist can be an angel. In the end, even he had to pay a price for giving himself over completely to his art. "At times like that, the sufferings one has inflicted on others, one begins to inflict on oneself equally. It's a question of the

recognition of one's destiny and not a matter of unkindness or insensitivity."[2] Surrounded by a court of hypocritical flatterers, the price the great man paid for his genius was monumental solitude.

But this is not the story of a great man but of a great woman—the only one Picasso was forced to recognize as his equal. The painter Françoise Gilot knew that Picasso, the most famous artist of his time, who over three decades had become accustomed to flattery and admiration, was, in reality, the loneliest man in the world. When she got to know him in 1943 he had long been living in his own inner world, where he shut himself away from society's unreasonable demands.

She had an inkling of what she was letting herself in for. Picasso himself had warned her that every love lasted only a certain period of time. She knew she was going to have to live with Bluebeard's former wives, and she saw clearly that all her predecessors, as different as they were, were eventually pushed off the stage. "They all had different kinds of failures, for very different reasons. Olga, for example, went down to defeat because she demanded too much. One might assume on that basis that if she hadn't demanded too much and things that were basically stupid, she wouldn't have failed. And yet Marie-Thérèse Walter demanded nothing, she was very sweet, and she failed too. Then came Dora Maar, who was anything but stupid, an artist who understood him to a far greater degree than the others. But she, too, failed, although, like the others, she certainly believed in him."[3]

IN CONTRAST TO her predecessors, Françoise Gilot entered her adventure with her eyes wide open. "I knew it was going to be a catastrophe," she told me, "but a catastrophe that would be worth living."

I was familiar with catastrophes from my own experience. But the fact that they could be worth the price they exact was something new to me. So I broached the subject again: had she ever regretted getting involved with Picasso?

She just laughed. "Regret is a complete waste of time. Apart from that, it is much more interesting to experience something tragic with an exceptional person than to live a wonderful life with somebody mediocre. It's wrong to think that you can find peace with someone average, because often that person will take longer to destroy you, especially if you are a woman!"

Wasn't she right? Isn't it often our own fault that our lives seem boring and dull? Because we set out timidly and carefully to find safety and lazy compromises, just as we were brought up to do? And isn't it often women themselves who let men destroy their lives when they allow themselves to be forced into the traditional roles of housewife and mother, until they somehow give up of their own accord on making their secret dreams come true? Despite all the feminist debates and equal-opportunity initiatives, the stereotype that a woman cannot really combine a career and a family still prevails. Françoise Gilot's life proves, however, that it is possible for a woman to succeed in a man's world. Her success depended not on hiring quotas, but on her own personal courage and energy.

Françoise Gilot reminded me that self-satisfaction and routine are the greatest obstacles to a happy life, for happiness has its price. "If you want to really live, you must risk living on the edge; otherwise, life isn't worth it. When you open yourself to risk, you will also experience bad things, but mostly you will learn a lot and live and understand more and more. Most importantly, you will not be bored. The very worst thing is to be bored."

The legacy of this extraordinary woman is greater than her paintings and her books. She is a philosopher of joy, who can find laughter even in the darkest moments of the tragicomedy of her life.

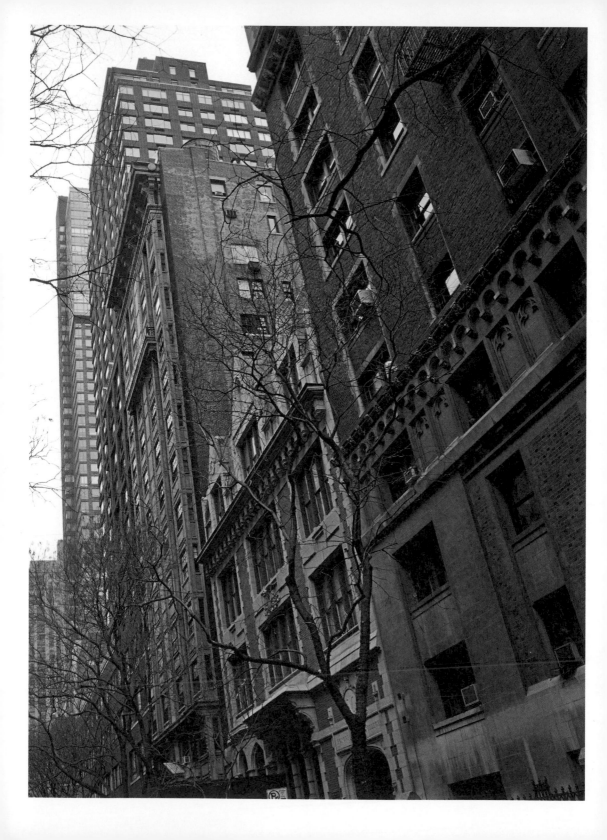

"Life is movement, the universe knows no stillness. From atoms to galaxies everything quivers, throbs, moves, unfolds, coils up, ripples, expands, radiates, multiplies, eludes, huddles up, branches off, augments, dwindles. All is part of the huge cosmic dance where the only constant is change."

FRANÇOISE GILOT, *Monograph 1940–2000*

NEW YORK

DANCE
THE FIRST LESSON

NEW YORK ON a hot afternoon in July. I entered an ivy-covered hundred-year-old apartment building that lies on a side street only a few steps away from Central Park West. At the end of the hallway stands an ancient elevator with a brass lever that looks like a ship's instrument. It was operated with nautical efficiency by a liveried porter. We made our way ceremoniously up to the first floor, where Françoise opened the door.

She was completely in red: dress, stockings, shoes, and once again, this incredible vitality. Since my first visit to her Paris studio, I had been fascinated by the uncanny rigor and power with which she lived her life, unrestrained by external standards. She was like a nun who had invented a god to have someone she could pray to. What she said about the search for truth was exactly the same as the message from a service I had just attended after I had happened upon an open church in midtown Manhattan—a perfect truth you can strive for that transcends philosophical and religious differences. I wanted to set out in search of the authentic life, and I knew that I had to begin with Françoise.

< Françoise Gilot's apartment building near Central Park West, New York.

LIFE. IT'S NOT SO BAD. Of course it can never compete with art. Life lasts for a short time, and art lasts for a long time. Hippocrates knew that a long time ago, and he was a doctor after all. But isn't there also such as thing as the art of life? "You've come to the right place." Françoise chuckled. "It's all a question of what you want. What matters is not how things are but how you react to them."

That's another reason why I was visiting her again, and the longer I listened to the old philosopher, the younger I felt. "Life is more malleable than you think," she explained. "It's as stretchy as a rubber band. Of course, there are immovable stones on every path, but people are elastic. We can stretch ourselves out and pull ourselves back together. We must just be careful that we don't pull ourselves together too much."

But woe to the individual who stretches the band so far that it breaks. Everything is an art, and every expansion has its limits. It's all a matter of fixing one's life's goals securely so that they don't slip their moorings. "When I was a young woman, I often sat with my legs in the splits. I was good at doing the splits, and I came up with a motto: to live the splits. I wanted to always be at one extreme or the other and never in the middle. Today we are brought up to live in the middle as safely as possible, but extremes are unbelievably important. Naturally, you will live a life with more danger but also with more happiness."

Even though I was only half her age, I knew the price of such a life: the breathtaking moments of joy but also the vertiginous tailspins into depression and pain that often follow such emotional heights. Wasn't it better to live in moderation instead of making extremes a virtue as she did? But Françoise, who had experienced so much more than I had, would have no truck with that.

She had anticipated my objection and cried triumphantly: "Ahh, but you can never avoid pain! It will find you one way or the other. So you must try your best to approach life a different way. The more you experience, the greater the probability that some of your experiences will be unpleasant. But does that mean that it is worth living a mediocre, so-so life instead of risking more?"

The old woman's energetic voice left no doubt that it certainly wouldn't be worth it as far as she was concerned. "Mediocrity is the very worst. The Romans said that virtue lies in the middle, but they were completely wrong

about that. In the middle there is nothing but mediocrity. Virtue lies in the extremes. Sometimes you destroy a few things, but even then, it's worth it."

That had always been her philosophy, so now she was in no danger of spending her old age regretting missed opportunities. Was that the reason that despite her feisty energy, she radiated an extraordinary peacefulness and serenity?

She had not only surrendered to fate—that alone calls for a composed courage that very few people can achieve—but she had also defied it time and again. She often suspected things were not going to end well, but still, she did not want to miss the experience. In Françoise Gilot's life, right next to the highlights there were the catastrophes that she had not wanted to avoid. "None of us lives forever. Look at me. Even though I've taken many risks, I'm still alive at ninety." She laughed and continued, "And I'm not doing so badly, am I?"

She was right. In front of me was living proof that it is better to keep moving than to stand still. Life is a pendulum that should only stop in the middle when it is over. It is movement to a ceaseless beat, and this movement passes into all living things.

"Look at a horse. It doesn't move just any way. It gallops to a very particular beat." Françoise knew what she was talking about. Horses are her passion. When she was just a little girl, she rode through wooded parks in Paris, and she knew how to get her horse to dance, because she was so in tune with its movements.

"Everyone must find a personal rhythm that is in harmony with the world," Françoise explained. Life is improvisation. There is no composer who writes the score for us. We have only the rules of harmony and meter to guide us. Life is jazz, a sequence of riffs and blue notes. But how difficult it often is to find this rhythm before our piece fades away and the curtain falls. Paralyzed by stage fright, we hit wrong notes and wait in vain for applause before we notice the room is empty—that it always has been empty—and that we are playing only for ourselves.

"No matter how old you are, you must behave like the ocean," said Françoise. "Watch the movement of the waves, the coming and going of the tides. All life has movement, rhythm, a momentum you must seize like a dancer, and if you allow this movement to flow through you, then you become one

with the rhythm of life." Not everyone is an ocean. Even geniuses some-times feel like reservoirs in midsummer. But it is not a question of size but of rhythm.

But how are we supposed to find the rhythm of the universe if we are constantly focused on ourselves, and this makes us stumble over our own feet?

"That happens because you are paying attention only to your ego and not to your self. The self has no form and no substance." She gave a hearty laugh. "Apart from that, you are a man! You poor men have it far harder because you have always been brought up to prevail and bring order to the world."

PEOPLE TODAY HAVE lost the knack of giving themselves over to Nature. The cerebral cortex is to blame, creation's crowning glory, which went to people's heads long ago. It has subjugated Nature and thereby lost the connection to the source of being. In the modern world, natural movement has been lost to horsepower, timetables, and maps. If it were up to the modern economy, the rationalized, optimized human being of today would move only from one square to the next so that the beginning and the end of the journey could be calculated in advance. Economic geometry is not designed to allow people to break out of the grid.

Nowhere is this more obvious than outside the atelier, where the mapped-out city spreads a uniform network of streets over the island of Manhattan, streets that, for ease of reference, have been assigned ascending numbers rather than names. As a pedestrian in New York, I had, until now, always regarded this as an advantage, because it meant you didn't need a map. But as I listened to Françoise, the cold chessboard logic of the city suddenly took on sinister overtones. I averted my gaze from the world outside the window and examined the large paintings that hung on the studio walls instead.

I saw an ape, a parrot, and an owl, around which were grouped a series of abstract, geometric shapes. Françoise had painted the two-and-a-half-by-one-and-a-half-meter picture in 1966 and given it the title *Cyclical Space.* And indeed the Cubist shapes could not conceal the fact that there was a circular relationship between the creatures, and the dynamic was emphasized by a diagonal line on the canvas. Of all animals, the ape is most like a human being, and the ape was looking mutely at the parrot, which, although it can

speak like a person, is not a person at all. "And the owl," explained Françoise, laughing, "looks at all this and says nothing."

The painting offered an alternative to the regulated plan of New York's network of streets outside our door, and suddenly I realized it isn't just music and language that can imitate life's beat but also an apparently static painting. Not only the lines but also the colors in their apparent confusion formed a new dynamic that appeared to make countless experiences and discoveries possible. The longer I contemplated the picture, the more insistently its rhythm entered me, and I began to understand what Françoise meant when she said you had to trust yourself to life's movement if you were to discover anything new. You couldn't simply analyze this picture and then reduce it to a clear message. It could not be translated. But standing before it, you could in some indescribable way feel something come over you as you looked at it.

"Painting is a way for me to explore the great unknown and to find new rhythms, colors, and shapes for myself," Françoise explained. "You have to react to the world. You have to be active and not half-dead. We must live as long as we are alive."

City living is no excuse. "You can surrender yourself to the rhythm of life even on a short walk." You have to execute even the smallest movements with your whole being and transfer your imagination from your mind into your body. She pointed to the treetops on Sixty-Seventh Street moving gently in the breeze outside the window. "Look at how that leaf there is moving. It has a particular rhythm. Do you see it?" The ninety-year-old stood up and began to turn and sway. "If I want to, I can tune my body to this rhythm at any time, on a walk or in the studio by the window." It was a dance without music and her movements were still lithe. The body is important as well as the mind.

Piano music wafted over to us from the window of a neighboring apartment. Someone was playing Claude Debussy's "Claire de lune." She listened carefully to the notes. "Follow the pulse of the music and stand up. If you're not up for that, at least move your arms in time with the music." Françoise smiled contentedly and laughed while I moved my arms through the air like a conductor. "That's right. That's why conductors live so long, because they are always doing that. We painters do it too with our brushes. Do you know why Titian and Tintoretto got to be so old, even though the plague was raging all around them? Because they were too busy painting!"

Dance

CÔTE D'AZUR, FEBRUARY 1946

MATISSE

"VERY GOOD. HE'LL love the colors." Picasso was like a little boy as he gleefully examined Françoise, who was sitting between him and his driver, Marcel, on the front seat of the big Peugeot. She had chosen the mauve blouse and the willow-green pants with care to please her artistic idol. Henri Matisse! She was fifteen when she first saw his paintings at the 1937 Paris International Exposition, and right away she was captivated by their audacious ferocity and the intensity of the colors.

Although he owned a big car, Picasso never took the wheel himself, because he was afraid his hands might lose their suppleness. Instead, he allowed himself the luxury of a personal driver. "Pablo liked to come across as a simple person," Françoise had confided to me at our last meeting. "Nevertheless, he ran down artists like Vlaminck, who wore wooden shoes stuffed with straw. He found that crude. He liked to say, 'An artist must be too poor to be able to afford a cow but rich enough to have a driver.'"

Trusty Marcel had already been in his service for many years. He had the sharply delineated features of the imperious heads you find on ancient

Roman coins, and he was the only one whose disapproval Picasso not only tolerated but seemed to positively enjoy.

As Picasso liked to ask his driver for his opinion on his new works, Marcel had become an accomplished art connoisseur, and he could spot a forgery better than any gallery owner. Naturally, he was also an accomplished driver; however, the years in the south of France, and above all the liberal consumption of pastis, had made him throw caution to the wind. The Peugeot raced with alarming speed along the coast road. Only Picasso was completely unimpressed by Marcel's breakneck tempo.

In the summer of 1945, Picasso had rented a small apartment with a view of the harbor in the fishing village of Golfe-Juan on the Côte d'Azur, and he had pressured Françoise into living with him. She had hesitated for a long time, because she knew that moving in could arouse Picasso's possessiveness and spell the end of her freedom. Finally, she agreed, and in February the following year, she moved into the grandly named Villa Pour Toi (For You), to work on some etchings far away from Paris's wet winter weather.

As Matisse lived only a half hour to the north by car, in Vence, a few days earlier, Picasso had suggested they pay his friend a visit. "He lives in a house called Le Rêve (The Dream) on the Route de Saint-Jeannet. I will call Lydia Delectorskaya, his secretary, and tell her that I am bringing along a young painter who greatly admires him, and when she says yes we'll leave right away."

Françoise was delighted with the idea, but she took great care not to give herself away to Picasso, and she feigned disinterest when she asked about Matisse's home. For all she knew, her enthusiasm might make him jealous later, and he might change his mind just to torment her. A few weeks earlier, she had had to turn down an invitation to visit Pierre Bonnard after Picasso had fallen into a fit of rage. This time, however, he had come up with the idea, and thrilled at the prospect of seeing his old friend again, Picasso had immediately set about putting his plan into action.

Soon they passed Antibes, and Marcel raced on northwards through a hilly landscape daubed with cypress and olive trees, finally screeching the car to a halt in front of an ochre-yellow house with a red-tiled roof. Hidden behind tall shrubs and palm trees, Le Rêve stood in front of them.

Matisse's secretary, Lydia, opened the door and led them through a series of increasingly dark rooms. Once Françoise's eyes had adjusted to the dark,

she made out the outlines of objects. A blue earthenware jug with white polka dots stood on a table over there; a pineapple lay on a garden chair. They looked like objects in a painting, and indeed she found the same earthenware jug in a picture that hung on the studio wall. It was as though the objects had been painted into existence—and by none other than the great Matisse. They had become Matisse-objects; his gaze had formed them and then peeled away their mundane properties as though freeing butterflies from larval cocoons.

45

In the next room, there was an immense cage in which exotic birds sang. White doves, Matisse's favorite bird, were hopping about freely in the room and seemed to want to entice the master over with their soft but insistent cooing. At the windows, colorful Tahitian curtains waved in the wind, offering the occasional glimpse of a palm tree outside. Matisse had painted the tree as well, but in the eyes of the beholders, the original and the copy had changed places and it looked to them as though the palm tree outside was merely a copy of the other, real palm tree in the painting. The villa lived up to its name.

Matisse was waiting for his guests in the final room. Bathed in the bright light of day, he was sitting up in bed, cutting shapes out of colored paper with an enormous pair of scissors. As a result of a serious operation in 1941, Matisse spent most of the day either in bed or sitting in a wheelchair, which had not put a damper on his urge to create. A box of carefully sharpened lead and graphite pencils stood on a small turntable. Below were his tools, his Tahitian wrap, and the painkillers he needed since his operation. He called them his "happiness pills."

When Picasso saw how neat and well-organized Matisse was when he worked, he took the opportunity to complain a bit about Françoise. "You can count yourself lucky that you have someone who arranges everything for you so tidily. When I look for a pencil, the point is always broken, and if there's a good one, Françoise always says it's hers. She's a real egotist. She always concentrates on her own work and never offers to help me."

Before Françoise could protest, Matisse responded with a sympathetic smile. "I'm really sorry for you, you poor thing!"

He had picked up a long stick of bamboo and fastened a piece of charcoal to the end of it so that from his bed he could mark on the sheets of

paper hanging on the wall where Lydia should attach the paper cutouts. "I call this drawing with scissors," he explained to his guests. He'd obviously been working for some time, for the bedspread was strewn with colorful snippets of paper—much to the delight of his cats, who kept him company while he worked.

46

Françoise was completely fascinated by him. Matisse had the aura of a genial Buddha. Despite his girth, he seemed to her to be weightless and no less energetic than Picasso.

THE ART WORLD liked to think of the two greatest painters of their time as rivals, but in fact they were friends, helped not only by an age difference of a good twelve years but also by their completely different temperaments. Matisse, on the one hand, came from the north of France, and his polite and serious demeanor matched the natural disposition of the inhabitants of his homeland. Picasso, on the other hand, came from the southern tip of the Iberian Peninsula, and with his fiery demeanor he was the complete opposite of Matisse, who sometimes joked: "We are like the North Pole and the South Pole." To which Picasso retorted: "Yes, because the South Pole is colder!"

Whereas Picasso liked to play the radical and provocateur even into his sixties, Matisse, with his friendly blue eyes and meticulously trimmed, full white beard, came across as something of a kindly father figure, and he took a paternal interest in Picasso, who, unusually for him, enjoyed this dynamic.

Françoise felt the special relationship between the two and slightly envied Matisse, because he could be sure of the unpredictable Spaniard's affection without having to fight for it. "Whatever has been said or written to the contrary, this was the one relationship in which Pablo was extremely careful not to be negative in any way. It was rather touching to see how patient and flexible he could be in order not to challenge or hurt his friend's feelings."[1]

The friendship did not stop them both from openly exchanging opinions on artistic matters. After Picasso had introduced her as a young painter, Françoise said hello politely and then contented herself with listening to the two men talk, while she happily determined that her green pants exactly matched the color of the hand-knit sweater Matisse was wearing. This was

more than a question of fashion. Convergences of this sort in the world of color that she, as an artist, shared with Matisse and Picasso created a sort of magical harmony. In their world, colors were neither random nor matters of personal preference.

Françoise watched, fascinated, as Matisse continued to boldly carve the colorful sheets of paper into intricate designs. "Delicately holding the piece that suited his purpose in his left hand, he wound it and turned it while his right hand skillfully cut the most unpredictable shapes. Women, vegetation, birds, dancers, bathers, starfish, abstractions—a complete world emerged from his hands, full of strength and vitality."[2]

Picasso, as he always did, asked after his colleague's latest works. After Lydia had brought out a series of paintings, Picasso pointed to a canvas of two women in a room. One of them was naked and painted in shades of blue. Picasso grimaced. A naked figure might belong in such a composition but not a blue one. "This nude needs pink," he instructed Matisse, who responded with a smile and promised to change the color. Then he turned to Françoise with the words: "I really should paint your portrait some time, and when I do I will paint your hair green."

Before Françoise had time to feel flattered, Picasso's suspicion was already aroused. "But why do you want to paint her portrait?"

"Because she has a head that interests me, with those eyebrows that look like circumflex accents."

"You can't fool me," countered Picasso. "If you want to paint her hair green, it's only so it goes with the Oriental rug in the picture."

Matisse laughed. "And you would paint the body blue so it goes with the red tiles on the kitchen floor."

Sitting on the sidelines, Françoise contemplated the fact that her color could spark a cockfight in the studio. Matisse was obviously enjoying pretending he had no idea of her relationship with Picasso, since Picasso had introduced her simply as a young artist and not as his lover.

As the two men debated back and forth, Matisse continued creating his fantastical shapes. "The cutouts went on dropping joyously over the bedspread. Up to that point Matisse had been busy creating designs but had not assembled anything. All of a sudden he retrieved a tiny black shape that had fallen during the elaboration of a larger form. He looked at it. 'It is a portrait

in profile of Françoise with her long hair—a small figure kneeling. Now I see what I must do.'"³

While Picasso watched him suspiciously, Matisse grabbed a sheet of green paper and held a bright red and a black snippet of paper up against it to check how the colors contrasted with one another. Then he used his scissors to cut seaweed shapes out of the smaller pieces and he laid them next to Françoise's profile on the green sheet until he was satisfied with the organization and proportion of the elements.

Françoise watched mesmerized, and even Picasso was fascinated by the easy, matter-of-fact way his friend moved the pieces around to find the perfect combination. Finally, there was only a scrap of paper left. In comparison with the other organic elements, it was very jagged. Where should it, where must it find its place in the composition?

Decades later, I reminded Françoise of the magic of the creative moment she had witnessed.

"We were spellbound, in a state of suspended breathing, knowing that Matisse was about to locate the remaining part. But he did not hesitate at all; he seemed driven. Slowly but with determination his fingers brought down the chiseled, three-lobed form and applied it firmly to the lower right side of the apple-green surface. It was just perfect. It all closed in, achieving instantaneous unity, with enough balance but not too much, with enough tension and enough rest, enough feeling of danger and of elation, enough zest and respite—a complete satisfaction for the being, for the mind, for the senses. A fragile masterpiece was there in front of us, defying eternity.

"In the impressive silence that followed, Lydia, armed with pins, managed to attach the five forms to the background without displacing them. We sat there like stones, slowly emerging from a trance. We had traveled with him all the way, in complete empathy with his every movement and decision."⁴

Françoise beamed when Matisse took the sheet of paper, signed it, and handed it over to her, while Picasso made faces like a child who had just had his ice-cream cone taken away from him. He didn't calm down and look happy until Matisse made another of his mysterious paper cutouts, this time of Picasso, and handed it to his friend. But the notion that another man— and his friend Matisse of all people!—wanted to paint Françoise's portrait gnawed away at him.

On the way home in the car, Picasso exploded: "Really, that is going too far! What would he say if I wanted to paint a portrait of Lydia?" It was an uncomfortable reminder that in the three years he had known Françoise, he had only painted two small portraits of her and only in black and white and shades of gray.

Even he was surprised by his negligence. He had done everything to get her to move in with him, and in all that time, he hadn't given any thought to making her the subject of a large painting. Was he being careful, was he holding back, was he too sure of himself? Their joint visit to Matisse had shown him one thing for certain: he wanted to possess Françoise as a work of art as well as as a person.

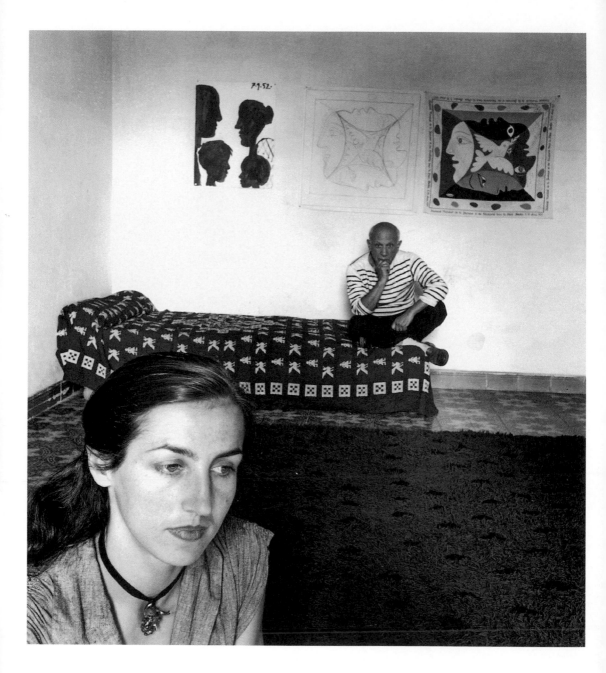

With Picasso in Françoise Gilot's house,
La Galloise, in Vallauris (1951).

LA FEMME-FLEUR
(WOMAN-FLOWER)[1]

In Françoise's own words:

DURING THE FIRST *month after I went to live with Pablo, I never left the house. Most of that time I spent in the studio watching him draw and paint. "I almost never work from a model, but since you're here, maybe I ought to try," he said to me one afternoon. He posed me on a low tabouret, then sat down on a long green wooden bench—the kind one sees in all the Paris parks. He picked up a large sketching pad and made three drawings of my head. When he had finished, he studied the results, then frowned.*

"No good," he said. "It just doesn't work." He tore up the drawings.

The next day he said, "You'd be better posing for me nude." When I had taken off my clothes, he had me stand back to the entrance, very erect, with my arms at my side. Except for the shaft of daylight coming in through the high windows at my right, the whole place was bathed in a dim, uniform light that was on the edge of shadow. Pablo stood off, three or four yards from me, looking tense and remote.

His eyes didn't leave me for a second. He didn't touch his drawing pad; he wasn't even holding a pencil. It seemed a very long time.

Finally he said, "I see what I need to do. You can dress now. You won't have to pose again." When I went to get my clothes I saw that I had been standing there just over an hour.

THE FOLLOWING DAY *Pablo began, from memory, a series of drawings of me in that pose. He made also a series of eleven lithographs of my head, and on each one he placed a tiny mole under my left eye and drew my right eyebrow in the form of a circumflex accent.*

That same day he began to paint the portrait of me that has come to be called La Femme-Fleur. *I asked him if it would bother him to have me watch him as he worked on it.*

"By no means," he said. "In fact I'm sure it will help me, even though I don't need you to pose."

Over the next month I watched him paint, alternating between that portrait and several still lifes. He used no palette. At his right was a small table covered with newspapers and three or four large cans filled with brushes standing in turpentine. Every time he took a brush he wiped it off on the newspapers, which were a jungle of colored smudges and slashes. Whenever he wanted a pure color, he squeezed some from a tube onto the newspaper. From time to time he would mix small quantities of color on the paper. At his feet and around the base of the easel were cans—mostly tomato cans of various sizes—that held grays and neutral tones and other colors which he had previously mixed.

He stood before the canvas for three or four hours at a stretch. He made almost no superfluous gestures. I asked him if it didn't tire him to stand so long in one spot. He shook his head.

"No," he said. "That's why painters live so long. While I work I leave my body outside the door, the way Moslems take off their shoes before entering the mosque."

Occasionally he walked to the other end of the atelier and sat in a wicker armchair with a high Gothic back that appears in many of his paintings. He would cross his legs, plant one elbow on his knee, and, resting his chin on his fist, the other hand behind, would stay there, studying the painting without speaking for as long as an hour. After that he would generally go back to work on the portrait. Sometimes he would say, "I can't carry that plastic idea any further today." And

then begin work on another painting. He always had several half-dry unfinished canvases to choose from. He worked like that from two in the afternoon until eleven in the evening before stopping to eat.

There was total silence in the atelier, broken only by Pablo's monologues or an occasional conversation; never an interruption from the world outside. When day- light began to fade from the canvas, he switched on two spotlights and everything but the picture surface fell away into the shadows.

"There must be darkness everywhere except on the canvas, so that the painter becomes hypnotized by his own work and paints almost as though he were in a trance," he said. "He must stay as close as possible to his own inner world if he wants to transcend the limitations his reason is always trying to impose on him."

Originally, La Femme-Fleur was a fairly realistic portrait of a seated woman. You can still see the underpainting of that form beneath the final version. I was sitting on a long, curved African tabouret shaped something like a conch shell, and Pablo painted me there in a generally realistic manner. After working awhile he said, "No, it's just not your style. A realistic portrait wouldn't represent you at all."

Then he tried to do the tabouret in another rhythm, since it was curved, but that didn't work out, either.

"I don't see you seated," he said. "You're not at all the passive type. I only see you standing," and he began to simplify my figure by making it longer. Suddenly he remembered that Matisse had spoken of doing my portrait with green hair and he fell in with that suggestion. "Matisse isn't the only one who can paint you with green hair," he said. From that point the hair developed into a leaf form, and once he had done that, the portrait resolved itself in a symbolic floral fashion. He worked in the breasts with the same curving rhythm.

The face had remained quite realistic all during these phases. It seemed out of character with the rest. He studied it for a moment. "I have to bring in the face on the basis of another idea," he said, "not by continuing the lines of the forms that are already there and the space around them. Even though you have a fairly long oval face, what I need, in order to show its light and its expression, is to make it a wide oval. I'll compensate for the length by making it a cold color—blue. It will be like a little blue moon."

He painted a sheet of paper sky blue and began to cut out oval shapes corresponding in varying degrees to this concept of my head: first, two that were perfectly round, then three or four more based on his idea of doing it in width.

La Femme-Fleur

When he had finished cutting them out, he drew in, on each of them, little signs for the eyes, nose, and mouth. Then he pinned them onto the canvas, one after another, moving each one a little to the left or right, up or down, as it suited him. None seemed really appropriate until he reached the last one. Having tried all the others in various spots, he knew where he wanted it, and when he applied it to the canvas, the form seemed exactly right just where he put it. It was completely convincing. He stuck it to the damp canvas, stood aside and said, "Now it's your portrait." He marked the contour lightly in charcoal, took off the paper, then painted in, slowly and carefully, exactly what was drawn on the paper. When he was finished, he didn't touch the head again. From there he was carried along by the mood of the situation to feel that the torso itself could be much smaller than he had first made it. He covered the original torso with a second one, narrow and stemlike, as a kind of imaginative fantasy that would lead one to believe that this woman might be ever so much smaller than most.

HE HAD PAINTED my right hand holding a circular form cut by a horizontal line. He pointed to it and said, "That hand holds the earth, half-land, half-water, in the tradition of classical painting in which the subject is holding or handling a globe. I put that in to rhyme with the two circles of the breasts. Of course, the breasts are not symmetrical; nothing ever is. Every woman has two arms, two legs, two breasts, which may in real life be more or less symmetrical, but in painting they shouldn't be shown to have any similarity. In a naturalistic painting, it's the gesture that one arm or the other makes that differentiates them. They're drawn according to what they're doing. I individualize them by the different forms I give them, so that there often seems to be no relationship between them. From these differing forms one can infer that there is a gesture. But it isn't the gesture that determines the form. The form exists in its own right. Here I've made a circle for the end of the right arm, because the left arm ends in a triangle and a right arm is completely different from a left arm, just as a circle is different from a triangle. And the circle in the right hand rhymes with the circular form of the breast. In real life one arm bears more relation to the other arm than it does to a breast, but that has nothing to do with painting."

Originally the left arm was much larger and had more of a leaf shape, but Pablo found it too heavy and decided it couldn't stay that way. The right arm first came out of the hair, as though it were falling. After studying it awhile, he said,

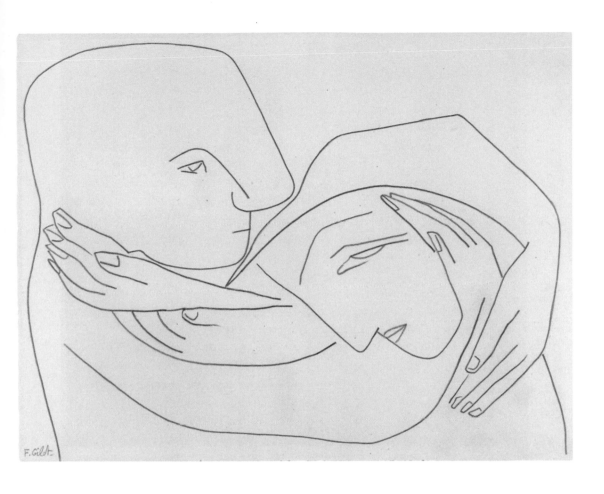

Picasso and I—The Embrace, 1948,
brush on paper, 50.2 x 65.5 cm.

"A falling form is never beautiful. Besides, it isn't in harmony with the rhythm of your nature. I need to find something that stays up in the air." Then he drew the arm extended from the center of the body stem, ending in a circle. As he did it, he said, half-facetiously, lest I take him too seriously, "You see now, a woman holds the whole world—heaven and earth—in her hand." I noticed often at that period that his pictorial decisions were made half for plastic reasons, half for symbolic ones. Or sometimes for plastic reasons that stemmed from symbolic ones, rather hidden, but accessible once you understood his humor.

In the beginning the hair was divided in a more evenly balanced way, with a large bun hanging down on the right side. He removed that because he found it too symmetrical. "I want an equilibrium you can grab for and catch hold of, not one that sits there, ready-made, waiting for you. I want to get it just the way a juggler reaches out for a ball," he said. "I like nature, but I want her proportions to be supple and free, not fixed. When I was a child, I often had a dream that used to frighten me greatly. I dreamed that my legs and arms grew to an enormous size and then shrank back just as much in the other direction. And all around me, in my dream, I saw other people going through the same transformations, getting huge or very tiny. I felt terribly anguished every time I dreamed about that." When he told me that, I understood the origin of those many paintings and drawings he did in the early 1920s, which show women with huge hands and legs and sometimes very small heads; nudes, bathers, maternity scenes, draped women sitting in armchairs or running on the beach, and occasionally male figures and gigantic infants. They had started through the recollection of those dreams and been carried on as a means of breaking the monotony of classical body forms.

When Pablo had finished the portrait he seemed satisfied. "We're all animals, more or less," he said, "and about three quarters of the human race look like animals. But you don't. You're like a growing plant and I'd been wondering how I could get across the idea that you belong to the vegetable kingdom rather than the animal. I've never felt impelled to portray anyone else this way. It's strange, isn't it? I think it's just right, though. It represents you."

Over the days that followed, I often noticed Pablo studying the wide oval head on my portrait. "As long as you paint just a head, it's all right," he said one day, "but when you paint the whole human figure, it's often the head that spoils everything. If you don't put in any details, it remains just an egg, not a head. You've got a mannequin and not a human figure. And if you put too much detail

onto the head, that spoils the light, in painting just as in sculpture. Instead of light, you've got shadow, which makes holes in your composition, and the eye can't circulate freely where it wants to. One of the possibilities open to you is to keep the complete volume of the head in its normal proportions, or even slightly larger, and to add, so as not to disturb the average viewer's habits too much, a minimum of small graphic signs close together for the eyes, nose, mouth, and so on. This gives him the necessary references to the various functional features. In that fashion you lose nothing in the way of luminosity, you gain an advantage for the composition of the painting as a whole, and you add an element of surprise. The viewer who is interested in the plastic problems involved will understand why you've done this and the interest it has. And for the viewer who understands nothing about painting, it becomes subversive: 'How can that man put only two dots for the eyes, a button for the nose and a bit of a line for the mouth?' he says. He rages, he fumes, he foams at the mouth. And for a painter, that's not a negligible accomplishment, either."

La Femme-Fleur

NEW YORK

SHE AND I

THE NEXT TIME I visited Françoise in New York, I searched the walls of her atelier in vain for the *Femme-Fleur* portrait that Picasso had painted of her in 1946. An old photograph shows the painting hanging in the studio she set up at her parents' house in Neuilly-sur-Seine after her separation from Picasso. I hadn't seen it when I visited her in Paris, so it had to be in New York. It was inconceivable that she would have locked away such a precious and personally significant painting.

Françoise laughed. "The femme-fleur stands before you, but you won't find Picasso's painting here. I sold it years ago and used the money to finance this atelier." It brought me up short when she said that. There was no doubt that a large atelier on Central Park was a good investment and Françoise was a pragmatic woman. Since the 1980s, property prices had likely risen to dizzying heights as quickly as the price of art had recently.

But why of all the paintings she possessed had she sold this very personal one—the only one Picasso painted for her and gave to her? It couldn't be

a case of needing the money, because Françoise had always managed to be financially independent. She had recognized early on that Picasso kept his other lovers financially dependent; therefore, from the beginning of their relationship, she had been careful to remain self-sufficient. Her parents had means and had welcomed their lost daughter back, even though they had never approved of her ten-year relationship with the "mad" painter. That had given her financial security so that she could leave Picasso. And the prices for her own paintings had risen over the years, so she had a comfortable income. She had taken the portrait with her when she left Picasso. Where was it now?

"I have no idea. Somewhere in a private collection." For once, Françoise's laughter did not sound as carefree as usual. It sounded relieved and irritated at the same time, as though there had indeed been something that she would never forget but that she did not want to be reminded of every day.

"Bah, I didn't even like it anymore," said Françoise with a dismissive wave of her hand. "And anyway, I knew it inside out. Why should I have to look at it every day?" And with that, she put an end to the conversation.

FRANÇOISE'S ATELIER WAS actually like a gallery, where old pictures were taken down from time to time and new ones hung—or the other way around. When one of her old paintings came up for auction at Christie's or Sotheby's and it interested her, she bought it so that she could once again study an original she hadn't seen for years.

"Wait, I'll show you a painting that I bought at Sotheby's in New York in May." She went to a pile of canvases leaning against the wall and came back holding a portrait of a young woman. It was her childhood friend Geneviève, who had once wanted to be a painter like Françoise.

"I bought it because it was the last portrait I painted of her. She died two years ago, and I thought it was time to bring back a painting of her." Françoise laughed. "Apart from that, it was a bargain at $15,000 or so. The reproduction in the catalog was so dreadful that no collector was interested in the painting, but I knew right away which painting it was. Fifteen thousand dollars was a ridiculously low price in comparison with the true value of the picture."

I knew that Geneviève had an important place in her work. Early on, during the war, Françoise had painted her friend over and over again. They

had attended the same boarding school, they had studied art together, and even during her ten-year relationship with Picasso, they had never lost contact. Indeed, it was Geneviève who had pressured her to leave Picasso after the "monster" had made her an indecent proposal one day. Taking advantage of Françoise's absence, he had suggested "getting her in the family way." Françoise knew her friend was telling the truth.

A few years later, however, they lost contact after Geneviève got married and decided to give up painting and dedicate herself to running an upper-class household and raising children instead.

"She wanted to be a painter as well, but she betrayed her ideal for a bourgeois life," said Françoise, "with a husband..." Even a half century later, she felt her friend's decision was a personal betrayal, and just that once, I thought I detected a trace of bitterness in Françoise's voice.

"As a matter of fact, I prefer the company of men, as I've learned that you can't trust women."

"Why not?"

"I've tried, and I've been disappointed."

"By Geneviève?"

"Oh, *elle!* By her above all. I was much more open with her than she was with me. I put everything I had into that friendship and got very little back from her, and somewhere along the line it dried up."

"She did not reciprocate your feelings?"

"Feelings or whatever it is that friends share. Apart from that, I resent women because, in the end, they always prefer a man over you. I'm not talking about a lesbian relationship but about a normal friendship. And then suddenly you are relegated to being number two. I've never understood that about women. After all, I can be friends with a woman and that has absolutely nothing to do with my relationship with men! But it is rare to find a woman who doesn't try to steal the man you love."

That was likely a generational problem, Françoise admitted. Today, she has women friends who are forty years younger than her and seem more honest and open. "Perhaps because young women today have finally found themselves and no longer need a man to complete them."

But Françoise did not have a high opinion of other women her age. "In the best case the friendship is peaceful, and in the worst case it is a burden.

She and I

Anyway, that one over there is also a portrait of Geneviève." She pointed to a painting above the sofa in the tiny sitting alcove at the far end of the atelier. It portrayed a beautiful young woman with a flowing mane of hair looking out of a window. "I painted that in 1987, even though by then I hadn't seen her in over thirty years."

It was not the only picture Françoise had painted after parting ways with her best friend. For a half century, she had allowed Geneviève to appear in her paintings as her alter ego.

It didn't seem to have much to do with keeping the memory of her friend alive. Françoise was too determined and single minded to give herself over to sentiment. When she bought her old paintings, she did so because she wanted to become reacquainted with her former self. The paintings she bought from time to time and hung in her atelier were not there to create a museum; they were there to spur her on.

How lacking in pride she is, I thought to myself. She studies her own paintings not because she finds them so splendid but because she is curious. This is not narcissism but an interest in self-knowledge, which has always been the noblest and, at the same time, the most problematic goal of philosophy.

"As long as I am interested in a theme, I keep the paintings—both the old ones and the pieces I've worked on in the past few years," Françoise explained. "Sometimes I recognize after a few months that a painting is not finished after all. Then I add a detail here or increase a line there. I never paint over a picture, however; I just develop the composition further."

Her mouth twitched in a malicious smile. "Do you know, my agents are rather unhappy with me at the moment, because I don't want to give them any new paintings from the last few years." She shrugged, as if to say although she understood the economics of the art market, she still had not the slightest bit of pity for the dealers and the public who lusted after new work.

"That's not the way to do it. It's as though you were writing a long book, and before you are finished someone demands that you surrender the first fifty pages." She had made it a rule never to sell paintings from her current year's work. After all, there were enough older ones and "people could just be a little bit patient."

And patient her collectors certainly needed to be, especially as the artist herself was sometimes in competition with them. I imagined the looks on

the faces of the auctioneers at Christie's and Sotheby's when a small elegantly dressed old woman appeared in public and bought back at auction paintings that she herself had made a half century before.

A little while ago, the winning bid for *The Painters,* a 1952 group portrait in which she had painted Picasso with the artists Édouard Pignon and Pierre Gastaud, with herself at the top right edge, was half a million dollars. Apart from the skillful composition of the figures, another reason the price might have been driven so high was that Picasso was particularly fond of this picture, because Françoise had not only included one of his drawings from the series *Le visage de la paix* (*The Face of Peace*) in the picture, but she had also painted him in his favorite outfit: a striped sailor shirt and slippers. This time, Françoise ceded the winning bid to another buyer.

"But I buy a large number of paintings," she explained. "People get old and die, and then the paintings come on the market again after a long, long time. I get all the auction catalogs sent to me, and if I see an old painting of mine and it interests me . . ." Françoise showed me another painting, dated 1943, with the title *Portrait in Black (Myself at Work).* A young woman sits in front of an easel, dressed entirely in black, with a paintbrush in her left hand and a serious, almost grim, expression directed at the canvas. I recognized immediately that I was seeing her, as a twenty-two-year-old in wartime. Her large eyes formed the fascinating focal point of the portrait, which was executed completely in gray and dark tones. With a bleak and melancholy, but at the same time concentrated, expression, she looked at the painting in the painting, which only she could see, because it stood with its back to the viewer.

"What's she painting?"

"You can figure that out for yourself," said Françoise, and she laughed. She didn't want to make it that easy for me.

"A self-portrait?" I ventured. "Perhaps the one from 1941, with the green background, that is even bleaker than this one here."

"Ha, ha, good idea. Who knows? Anyway, we can't ask her. She's keeping quiet."

What kind of a feeling was it to meet yourself once again as a young woman after more than a half century? How did this moment feel when the ninety-year-old met the gaze of the woman who was seventy years younger than she was? The painting was a mirror that warped time until the years dissolved away.

Françoise stood in front of the painting and regarded it carefully. "I recognize myself very well in that picture. Look at the way I am holding myself, upright like an equestrian, and I'm holding the brush like a rein. At the same time, the composition is very atypical, and that fascinates me. I'm sitting there completely in control. You can't see a single tense muscle, and even my face is expressionless and reserved."

Indeed, the body had a paralyzing lack of expression that was intensified by the force of the eyes. This young woman was painting during the war, and you got the feeling that a huge weight was bearing down on her, and she was hiding her quiet despair behind this severe façade.

Then Françoise told me how during the German occupation she would comb flea markets to buy bad paintings that she would then paint over. At the time, that was the only way to acquire canvases. When I asked her if she might perhaps have painted over a Rembrandt, she shook with laughter. "A Rembrandt? That would have been something. No, I'm sure that I didn't mistakenly... I'm sorry. The idea is just so funny."

WHEN SHE BOUGHT the self-portrait in black it was in an appalling condition. The previous owner had bent over the edges and put it in a smaller frame. "Sometimes I wonder about people," Françoise said, getting worked up. "They buy a painting and because they don't have a frame the right size for it, they make it smaller so it fits? But if you do that, the face doesn't have any space left to breathe!"

She shook her head indignantly and sighed. "And to make matters worse, most of them have dreadful taste in frames as well. There really are people who hang a modern painting in one of these awful rococo-style Louis xv frames, which don't go together at all. On what street corner did these people leave their taste? When I buy one of my old paintings, the first thing I do is throw the frame away and have it remounted in silver, mind, not gold, because silver allows the colors to come through much better instead of drowning them out."

Of course she was right. As an artist, you have to be thick skinned to put up with the taste of some buyers. As soon as paintings leave the atelier, they become commodities for whose purchase first and foremost money is required, and then perhaps in second place understanding and taste. I had

often heard of collectors of contemporary art who bought "blind," simply giving gallery owners or art consultants the task of purchasing them an appropriate portfolio of works. And what artist would not prefer to keep her own works herself if she didn't need money? I thought of one of the Russian writer Pushkin's sayings: "I write for myself, I publish for money."

The most important thing, however, was curiosity. There were collectors who seemed to have no idea where the real value of an artwork lay. Even if the worth of their investment multiplied over the years, these collectors had still made a bad bargain, because they had spent their lives with works whose true worth escaped them. For artists, it must feel as though they are entrusting their children to the care of brutish barbarians.

"Would you prefer to have all your paintings for yourself?" I asked Françoise one day, when she once again showed me a painting that she had just bought back. "No, but from time to time I find something I painted thirty or fifty years ago and had forgotten all about, so that is interesting." She pointed to a painting whose background was completely black and white. "Take, for example, these lines here. From the point of view of perspective, they are not correct. I am not a proponent of perspective, and sometimes I reverse proportions, and I always avoid symmetry. Naturally, I have developed my technique, but sometimes I notice things in earlier paintings that are really quite good."

When I asked her whether her work was sometimes directly inspired by these old paintings, she laughed. "No, no. Everything is tossed into a big salad. I renew myself, and I never repeat myself."

Indeed, there are very few artists who, in the span of eighty years, have achieved such a varied portfolio of work as Françoise Gilot. Staying true to herself, she never stands still, yet the mature artist has never lost the curiosity of the small child who more than ninety years ago first looked at the bright stripes of the curtains of her childhood bedroom as though they were a spectacle to behold.

"Life," said the Danish philosopher Søren Kierkegaard, "can only be understood backwards, but it must be lived forwards." When I left Françoise's atelier that evening and wandered down Fifth Avenue deep in thought, I knew what he meant.

She and I

Portrait in Black (Myself at Work),
1943, oil on canvas, 73 x 60 cm. ›

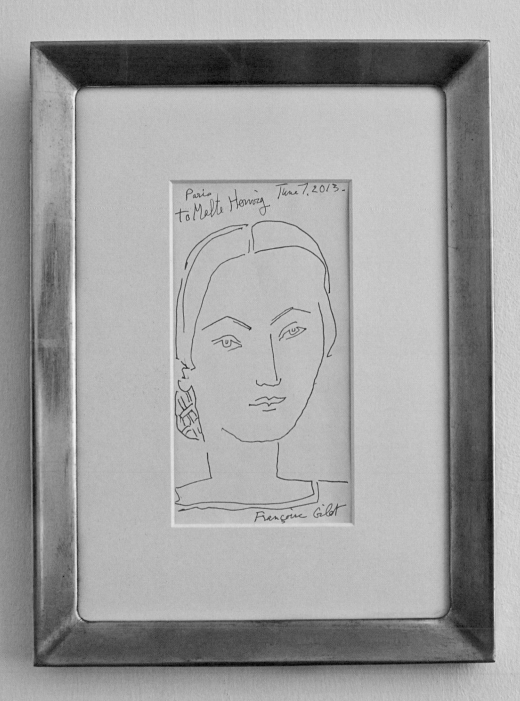

PARIS

FLY, BIRD
THE SECOND LESSON

O N ONE OF my visits to see Françoise in Paris, I asked her to draw a face. I gave her my notebook and a pen and watched as a portrait of a beautiful young woman appeared in minutes as she made brief, confident strokes. It was fascinating how she conjured up a face using the simplest of tools and without drawing a realistic likeness, like the sidewalk artists who sketched tourists in Sacré-Coeur.

Ever since I first grasped a pen, I have been bad at drawing. Art class in elementary school was a trial for me, exceeded only by lessons on the recorder. I just could not draw anything that even halfway resembled a human figure.

A miracle has no opposite, but as an artist I was the opposite of a miracle child. Even later, in high school, I did not make any progress. The teachers, all of whom were trained artists, bear in mind, must have thought the lessons were a particularly excruciating punishment for sins committed in a previous life, as I was not the only student in the class who was completely bereft of talent.

< *Beauty Instantly Birthed from Nothing,* 2013.

It was not just that my clumsy fingers lacked skill. Worse, any sense of perspective, mass, and composition packed up and left me. The world I brought to paper was flat, lopsided, and desolate—you really did not want to have to live there. Luckily, it also had nothing to do with the world around me.

I remember that once we were supposed to draw a tree in a landscape. I dipped my brush into the water glass, then in the box of watercolor paints, and I painted a mighty trunk with thick branches in saturated colors on the blank sheet of drawing paper. Next to me, my best friend, Marcus, was working away at the same task. The truth is that he was just as untalented as I was, but he was lucky. In the middle of his grand toil, he ran out of water and the colors became paler and the brush strokes took on a van Gogh–like impetuosity.

In the end, I got a two for my blob of a tree. Marcus, however, got a one for his painting, *Bare Tree in a Gathering Storm*. Unearned, as it seemed to me then, because he had just run out of water, yet also completely justified. When I look at his painting alongside mine today, it is immediately clear to me why it is better. Whereas I slavishly tried to paint a "realistic" brown tree while applying the paint as evenly as possible, lack of water forced him into abstract improvisation.

WHILE I ADMIRED the drawing of the young girl that Françoise had made in two minutes with short, feathery strokes, I confessed to her my complete lack of talent. Even at the age of forty, I could not draw a horse that anyone would recognize as such.

Françoise did what she always did when I confessed something embarrassing: she roared with laughter. "That's because you think figuratively. It's really very easy. When we see each other next time, I'll show you how it works."

When I saw her a few months later in her New York apartment, she didn't want to know anything more about it. "I said that I would show you how to draw?" she laughed. "That is absurd." But I didn't give up hope and reminded her of our conversation in Paris. Now Françoise squealed with laughter. "I must have been crazy. An attack of madness. We were in Paris, so I said I'd do it, but not in Paris. That is typical!"

When she caught her breath and saw how disappointed I looked, she took pity on me. "You have no idea if you can draw because you've never really tried." I explained to her that my drawings of horses looked as though they had been made more than twenty thousand years ago by a shortsighted cave painter suffering from whooping cough.

But Françoise wouldn't believe me. "That happens when the critic on your left shoulder is stronger than the artist on your right. If you don't believe in yourself, you won't be able to do it."

For me, it was more a question about being honest about my lack of artistic talent, but Françoise did not give up. "It's like swimming. If you tell me you can't swim, then I'll answer that it's very easy. Whether you swim particularly gracefully is another question. But you can easily move in the water without going under."

Her remarks reminded me of a series of paintings she had made in the mid-eighties of women swimming. She had chosen the unusual subject because she could think of nothing more old-fashioned than the nudes reclining on sofas that had served the erotic fantasies of male painters and viewers for centuries: "What could be more attractive than the bodies of female swimmers whose muscles are concealed and revealed by surf and waves?"[1]

Indeed, Françoise's swimming women seemed to be at one with the rhythm of the liquid elements. Their nakedness was elemental and therefore more potent that any erotic attraction. I told her I could understand the effect of the paintings. But that did nothing to change my inability to draw even a simple figure. First and foremost, Françoise explained to me, drawing is not a question of working with the hands; it begins with the eyes. "You don't succeed because you are thinking of everything all at once. You must have seen a falcon in a zoo. What do you remember most?"

Before I could answer, she continued. "Probably you remember the beak. Then the fantastic eyes, which are so small and yet so sharp that the falcon can spot his victim from over a hundred meters away." As Françoise was talking, she stood up and suddenly transformed herself into a falcon looking around the atelier for prey. Then she held her arms tightly to the side of her body and lifted her shoulders high. "This is what a falcon looks like when he is sitting on a branch. And this is what he looks like when he flies." She took a deep breath in, straightened her body—which looked

Fly, Bird

weightless and charged with tension right to the tips of its feathers all at the same time—and took off. "Now, when you draw the falcon, remember your observations and let him rise again from these elements." I understood that what it came down to was more the inner rhythm and dynamic of the movement of the magnificent bird of prey than external details. The secret of abstract representation is to allow reality to appear more authentically than in its outer form.

Françoise never painted from "real life." She no longer needed models or to view her subject. Over the course of ninety years, she had seen all the colors and forms of life and absorbed them into herself. Even Matisse, her great idol, painted objects and people that stood before him. There is a beautiful photograph of him drawing a dove with his right hand while he holds it in his left and scrutinizes it carefully.

"I don't need any of that anymore." Françoise laughed. "I draw from what is inside me. You must activate your memory, then you can draw the truth. Have you ever looked at a person's face and asked yourself what was the most important thing about it? Is it elongated or narrow or more square? When I see a face, I know immediately what shape is hiding behind the form, and this is the shape that you must draw. You don't draw everything you see. You only draw what you detect behind objects with the help of your experience."

"But I would still draw the outline of the falcon first."

"No," said Françoise sharply. "That is the last thing you do. First you need the content, then the container. And then you can start anywhere. When I paint a body, I don't need a silhouette. I could just as well start with the feet. You must paint from within yourself, and then you paint the truth."

I remembered a story about Rembrandt's workshop. The painter wanted to paint what became *The Adoration of the Magi,* and he commanded his apprentices to model for him. After the young boys—they weren't more than twelve or thirteen years old—had tried to pose for a while, Rembrandt lost patience and scolded: "That's completely wrong. You're not posing correctly at all. You have to assume the correct attitude with your whole body."

"That is very important advice," Françoise agreed. "You must feel it in your body, because it is your body that is doing the painting."

My glance fell on a painting hanging on the wall. It was of a falcon middive, and I imagined how Françoise, inside herself, had taken off and circled

The Mermaid, 1986, oil on
canvas, 100 cm diameter.

the high ceiling of her atelier and then suddenly shot down toward the easel until the bird of prey and the dynamic of its movement became one with the canvas.

Françoise smiled as she followed my gaze. "I paint with my whole body, with every cell in my body. I can't explain it in any other way. It really is a physical experience, and you need a certain innocence to do it, like a child."

The longer she spoke like this, the more curious I became, for it was clear to me that the drawing lesson I had stubbornly insisted upon was turning into a life lesson. My joking, if not completely absurd, comparison of my primitive drawing skills to those of a cave painter who had left behind pictures of his hunting adventures suddenly seemed to me to be way off the mark. In comparison with my ancient forefathers, I had not even left the cave. It seemed to me that I had walked through my life until now with my eyes open but without seeing anything.

Certainly, at the beginning of the twenty-first century, life is more colorful than ever before and we are bombarded with visual stimuli. Hardly a day goes by when we don't look countless times into the brightly colored confetti world of a smartphone or computer screen. Meanwhile, there are manufacturers of eyeglasses who advertise lenses that protect the wearer from "digital stress." Yet all the impressions I had taken in through my eyes seemed to have disappeared once they passed beyond my retinas. I had seen without understanding.

FRANÇOISE COULD ONLY laugh at my critique of modern civilization. "Everyone today has these amazing tools, and I think of myself as completely outdated because I do practically everything with my own two hands." The fax machine, which stood on top of the Art Deco dresser and was so far gone in years that it stopped working from time to time, was her only concession to technological progress.

Naturally, it is an illusion to believe our modern blindness is related solely to technological progress, for people have complained about progress regularly for centuries. Goethe wrote about how telescopes distorted perception. When photography came along in the middle of the nineteenth century, champions of progress predicted the beginning of the end for painting. When Françoise was born in 1921, Paris streetlights had already been

converted to electricity and the first movie theaters had been opened. She, too, could have complained of visual overload with a good conscience.

"When I was ten, my parents took me along to a bird shoot in Brière," Françoise told me. Early in the morning, she lay in wait to watch the birds as they rose in the sky at dawn. "I still remember how surprised I was that the wings of the ducks were positioned so far back in flight and that their necks were so long. When you've seen something like that, you remember it when you draw a duck."

I tried to imagine ten-year-old Françoise following the flight of a mallard in northern France, eyes wide open with amazement, until her father shot the bird and it plummeted like a stone to the marsh below. Françoise's laugh broke through my secret daydream. She guessed what was going through my head and said with an ambiguous grin, "I was, of course, against shooting birds precisely because my parents were in favor of it."

It had been clear to me for a while now that the fascination I felt for this old woman was not only because at ninety she could still laugh like a child and made use of this gift as often as possible. Even at thirty she had experienced more than some people do in a lifetime. Sixty years later, it seems as though no one could overtake her in life experience. That was no doubt not only thanks to good health but also to the single-mindedness with which she pursued her evolution as a painter. No one gets handed a "fulfilled life" on a platter. You need to go to the well, even when the jug sometimes breaks. She had experienced defeats and turned them into victories. She had learned rules and then had the courage to break them. But through it all, she had always relied on her own experience.

"You wouldn't believe all the things they tell you in art school," Françoise said one day in disgust. "For example, they preach that the most important part of the painting should be in the center and the less important elements belong around the edges. That is, of course, completely wrong. I always left an empty space in the middle and drew everything else around it—just to annoy my professors."

I countered with a maxim of my parents that you should break the rules only when you have mastered them.

"Of course, you should know as much as possible and master your craft," Françoise replied, "but it is only a means to an end."

Fly, Bird

"I have always forbidden my students to work according to strict rules. I was ten years old when I began to study art in earnest. So I have eighty years' experience, and I could paint a very good, very realistic picture. But I recognized early on that there's no point to that, and it doesn't interest me at all. Instead, I performed my own experiments and created my own experiences. I studied the chemistry of colors and I tested them out to see which ones had good chemical reactions with each other. For example, I discovered that you shouldn't mix cadmium and cobalt colors. The so-called rules are like that telephone over in the corner. If I don't want to speak to anyone, then I shouldn't pick it up."

I had to think of the big Jackson Pollock exhibition I had seen in the New York Museum of Modern Art a few years earlier. In the first room, a few of Pollock's earliest paintings from the forties were on display. I knew only the splatter and splotch paintings that had made him famous, and I was surprised by the accomplished realism of his early work. With a sense of discomfort I caught myself thinking like all philistines of art: he can paint after all! Obviously, the drip technique that became his signature style only looked primitive, and he hadn't developed it because he had no other skills at his disposal.

"We must work with our skills as we work with our mistakes," Françoise continued. "Take Bonnard. He couldn't draw at all. If we only had his drawings today...pfft!" With a dismissive wave of her hand, she swept Bonnard's drawings to one side to focus on Bonnard as a painter. "But how he combined color in his paintings and organized space—that was genius. He created something completely new because the strengths and weaknesses of his character demanded it!"

Doesn't the seed of all creativity lie right there? How easy it is to accept old ideas that are taken for granted as the only truth, to think of what has been done before as the given. But the greatest artistic skill cannot achieve anything really new. That can only be done by someone who is prepared to break the rules and find new ones that, in turn, need to be broken yet again.

"And you," said Françoise, giving me an encouraging look. "You are a person of the twenty-first century, and we want to know who this person is and what he is like. We don't want to know about a person who lived

two hundred years ago. It is wonderful when you experience something like that about yourself."

Once again, I saw that mixture of defiance and wisdom in Françoise's eyes. It was a seeming contradiction but one she had decided to live with. There sat the old, lively woman, smartly dressed in a fashionable red suit, toppling every piece of accepted wisdom that she had not come to through her own experience. Seldom had I got to know anyone who in the course of her life had so radically liberated herself from arbitrary conventions the way Françoise had. Without a doubt, no one can live without rules. But weren't the happiest people the ones who lived by rules they had freely chosen and discovered for themselves?

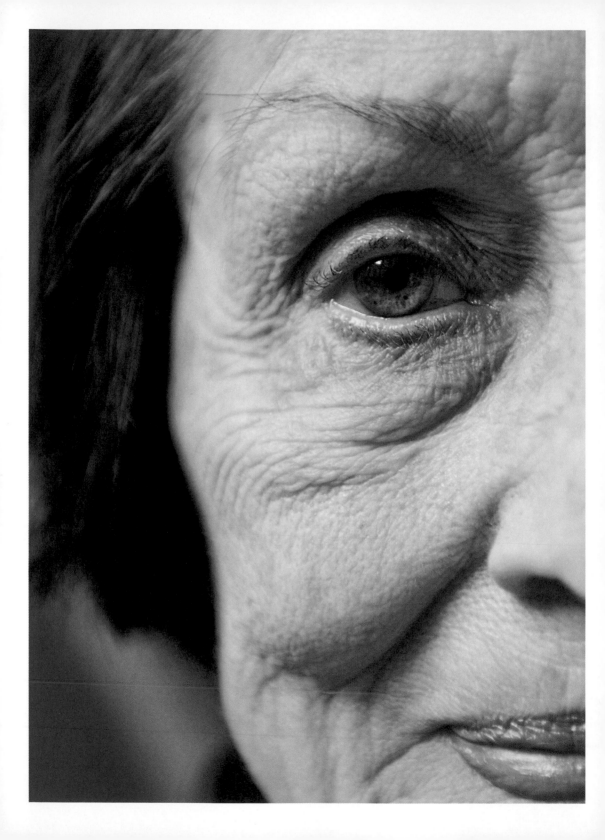

MISTAKES
THE THIRD LESSON

S HE STOOD ME up only once. I had flown to Paris and shown up outside
her atelier at the appointed time. But no one opened the door. There
was no noise from the apartment. I called her on the phone and lis-
tened while her telephone rang. As a journalist I was used to waiting, but this
time I was worried. Françoise was more than ninety years old, after all. She
always laughed about her health problems and her heart and spoke about
how everything could be over at any time.

Had she simply forgotten our appointment? Had she lost interest? Any-
way, it was not like her to simply not turn up. Slowly, I began to get concerned.
Because I couldn't think of a better idea, I called the Picasso Museum in the
hope that someone there might have her cell phone number. But nobody
could help me. After an hour, I returned dejectedly to my hotel and waited.
When I finally reached Françoise at her apartment, she professed ignorance.
"We had an appointment? I am so sorry. I was out. Why don't you come to
lunch tomorrow?" A weight lifted from my chest, and I decided to celebrate
the day by buying us a bottle of champagne from Ruinart.

When I rang the bell at the atelier the next day on the dot of noon, the housekeeper, Ana-Maria, opened the door. Soon after, Françoise appeared in a red dress. I asked her if she had already painted that morning. "No, no," she said dismissively and laughed. "I went to La Madeleine and shopped for us. Smoked salmon quiche and duck foie gras. I hope you like that kind of food." I do like that kind of food, though after champagne and foie gras, I could not imagine what we were going to do about the drawing lesson we had had planned for yesterday. "One step at a time," Françoise said. "But I thought if we were going to eat lunch together, it should be something good."

"First you get the most important lesson," Françoise said. "It comes from my mother, who was my first art instructor—and a very good one at that." She raised her distinctive circumflex eyebrows, and beneath them her eyes turned into question marks. "You must never erase anything! When you draw a line you must take care that it means something. Once it's there, it's there, and you must make something out of it."

"But what if I make a mistake?"

"Then you must work with it and add other elements until the mistake makes sense. That's why I always tell my students they should start with ink, preferably diluted with a little water. Then you can always change the composition. That doesn't work with darker ink. It's as though you were to make the last move first in a game of chess. If you do that, you will make the most awful mistakes, and you won't be able to do anything with them at all. I have often had students who wanted to make that last move first. But there's plenty of time to do that later.

"You must try out different things. Put a stroke here, draw a line there. Then you will suddenly notice that something appearing on the paper in front of your eyes begins to fascinate you. You notice a line you just didn't see before, and you begin to work with it. In the end, a mistake is no longer a mistake, because you have given it its own space and significance in the larger whole."

In that moment it became clear to me that Françoise wasn't talking just about drawing anymore but about life in general. It is not a disaster if you make a mistake. But you mustn't disown your mistakes or pretend they didn't happen, because they are a part of your life. It is much better to accept your mistakes and to work on them to give life a purpose in the end. Regret?

Never. Everything has its place in life, even the awful experiences. On a canvas, light achieves its radiance only in contrast to darkness—why should life be any different? Suddenly, I understood not only why Françoise accepted the beautiful moments of her relationship with Picasso but also why she did not want to do without the awful ones. They were part of an irreplaceable experience of joy and pain and knowing that she wanted to preserve in its entirety.

"That is indeed a philosophy of life," I said. "You try different things in life, you make mistakes while you're at it, but at the end what matters is that you take the whole path, with its twists and turns, and give it a sense of direction."

"People think that everything they do is a one-way street. But that is not true. Life is at least a two-way street, perhaps even a ten-lane highway. What am I saying? It's not a street at all but a series of toys that you make. Just like a drawing. Try it. Go in one direction, and if you don't like it, then try another. But keep this in mind: avoid the darkness and remain in the light, then you can always create something new out of it all."

FOR A WHILE now, on my travels as a reporter, in addition to my camera and my digital recorder I've always taken along a simple leather-bound notebook and a travel pen from Japan. Writing with ink on paper grounds me and makes me feel a little less dependent on the digital distractions in my surroundings. The physicality of writing forces me to concentrate, and now I was eager to put not just letters down on paper but other, more varied shapes.

When I set to putting Françoise's advice into action late at night in my tiny hotel room in Montmartre, I felt like I had grown new eyes. It was not that my blue, ink-stained fingers had become any less clumsy or could draw a perfect horse. But suddenly I could see a thousand possibilities in the dashes and circles they drew on the paper.

Until now I had always started with the outline of a shape. I had always tried to draw it as a clear, dark line, and I had done so hesitantly, because I did not want to make a mistake. The dark line was essential, and if it went wrong, I would get angry, throw the paper away, and start again, frustrated each time with the impossibility of outlining a particular shape with a single stroke.

Françoise had shown me that in itself was flawed thinking. "You don't always need to have anything particular in mind when you start. Set out in search of the happy accident. Leonardo da Vinci let himself be inspired by

the strange patterns he found on damp walls. Or in the seams in marble. Artists find form in such places and give those forms meaning. So you can start with something random that you find in a natural form, or you can nurture your own unexpected discoveries."

Drawing, Françoise explained, is an open dialogue with shapes where you must supply both the questions and the answers. I had to find the courage to constantly question what I saw before me and to see the whole in a new light with every stroke. "Most artists have no idea," she had said. "They demand that you know in advance what it is you want to do. But that approach doesn't lead anywhere. You must always start with something fluid, like watercolors or diluted ink, for everything that flows can also change. It's like a dance on the paper. You mustn't overthink things."

I moved the table in front of the window. In the distance, I saw the white towers of Sacré-Coeur shining in the night. I, however, wanted to start with the simplest thing I could think of—a circle. After I had diluted the ink with water until it left only traces of pale blue on the paper, I finally summoned the courage to draw with no particular goal in mind. With dozens of small strokes, I crudely outlined a circle. I made it larger, added strokes on top of strokes, and so darkened a section until suddenly a shadow appeared and the circle turned into a sphere. It wasn't a masterpiece, certainly, but for me, whose circles had always turned out like mangled car tires, it was a revelation.

I was impressed by the lightness and openness with which Françoise drew. With every line she entered new territory, with every stroke she might call the existing composition into question. There was no such thing as a mistake, Françoise had said, because out of every mistake something new could appear, whether the mistake was the artist's fault or not. That was the artist's task.

"The Greeks were a shrewd people," Françoise had said. "For them, in the beginning there was chaos and it consisted of these materials: carbon, silver, stone, and wood. Isn't that a wonderful idea? Chaos is not a muddle but the basis of creation. All you have to do is get the materials together and combine this one over here with that one over there. The possibilities are endless, and that never stops."

What would happen if we were to understand chaos as possibility? If we were to simply allow ourselves the freedom to make mistakes, because they can give rise to the new and unexpected?

"When you draw, you mustn't think about drawing," Françoise had said. "Simply start with something, add something, and then take a look at it. This bit here looks good. That one there doesn't really fit, so you change it. Don't mull it over for a long time. Like dancing, you have to keep moving. You will learn soon enough but not directly. Here you consolidate relationships, and over there you sever them. One takes over from the other. But never expect that a straight line will lead you to your goal. If I were to decide today to go from New York to Paris by bicycle, I wouldn't be able to take the highway!"

For me, the journey has never been the goal, and I have always taken the highway, even when driving from one small village to another. No wonder I seem to spend most of my time waiting in traffic or racing toward a pileup with my foot on the gas, and I never feel I'm getting anywhere.

Speed was something that Françoise valued for itself. She loved sports cars, and she had once owned a British Triumph Roadster and two Porsches. One time, she was racing so fast through the mountains of California that the police chased her in a helicopter and confiscated her driver's license. "Then I went with a girlfriend to an event where drivers who have sinned do penance and watch a film that shows all the things you mustn't do. It was terribly boring, and so we each brought along a mystery novel and secretly read."

With drawing, for Françoise, it's not about speed but decisive action. She hates hesitation and daydreaming. And sitting in traffic, no doubt she hates that as well. "With drawing, it's like being in driving school: the faster you drive, the easier it is."

AS I SAT in my hotel room, putting stroke after stroke down on the paper in front of me, it became abruptly clear to me that life was not a line, not even a wavy one. Life was a process, a series of toys. It was a collection of lines, strokes, and dots, whose relationships with one another could always change into something new. Life was movement.

I vowed to be more open to the unexpected, which until now I had thought of as being unimportant or, at the worst, as a trick played on us by fate—instead of understanding it as an opportunity to point life in a new direction. I decided I would learn how to see, and I would become more aware of things around me, instead of getting hung up on a line that was already drawn. And so the sketchpad with strokes on it would become my

Mistakes

map, and although the directions would always change, I wouldn't lose my way, because the new shapes would show me a new path.

Françoise had advised me to use ink diluted with water. That was also a lesson I wanted to take to heart. My preference would be to draw the trajectory of my life with a felt-tip pen and ruler as a straight line that rises steeply and ends at its highest point. But, of course, life isn't like that. And wasn't it better to move forward carefully, sometimes even stepping off the path, doubling back, and then advancing anew? I thought of a verse of T.S. Eliot's that had meant so much to me in my youth—even though I didn't really understand it until I was older.

> *We shall not cease from exploration*
> *And the end of all our exploring*
> *Will be to arrive where we started*
> *And know the place for the first time.*

There it was: the truth of the poet T.S. Eliot, the truth of the painter Françoise Gilot, an ancient truth known to Indian philosophers two thousand years ago. Life is not a given that we must suffer through but a possibility that arises when we encounter the world.

The world came into being, as Françoise had said, from the infinite materials of chaos, and our task, our opportunity, lies in our ability to contribute in our own way and make something out of it. That doesn't mean following some grand plan. Life is not painting by numbers. You must pay attention, be alert, develop a sense for changes, and be open to pursuing them. I suddenly understood why Françoise appeared so young to me. She was as agile as life itself—in harmony with the world not because she had molded it to her will, but because she flowed through it like a mountain river finds its way through rocky slopes down into the valley.

You've got to lighten up, I told myself, be less dogged and obstinate. If you look for something with cheerfulness and serenity, you can fail without remorse, for you will find another goal. If you make a mistake, you can make something new out of it. Choose the light ink and go for it.

Two Friends, 1953, oil
on canvas, 146 x 114 cm. >

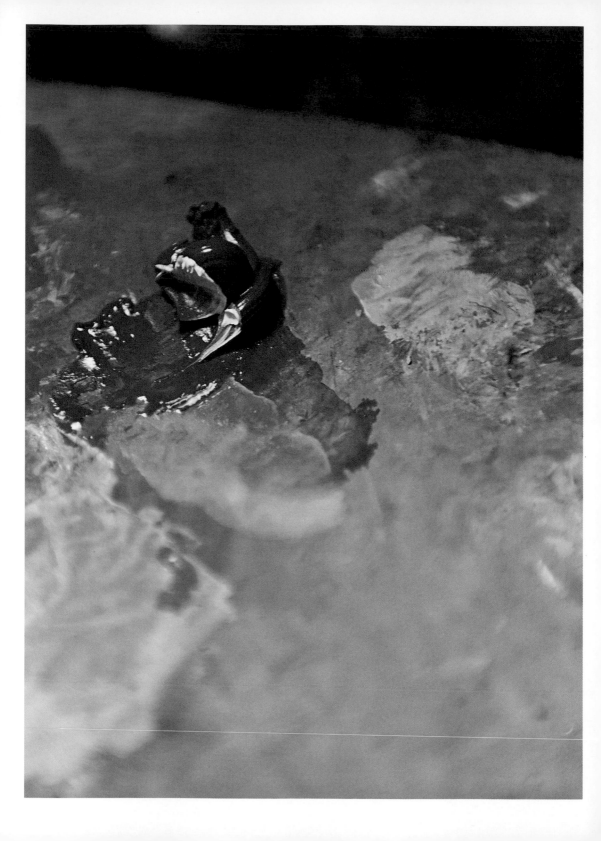

PARIS

CONTEMPLATING NOTHING
THE FOURTH LESSON

THE NEXT DAY, I was the one who was late for our appointment. I was just about to leave my hotel room, when I got a call from the editorial department. An article that was to appear in the next issue needed to be expanded in light of recent events. I typed up the piece while mentally calculating the shortest route through Montmartre.

When I finally got to Françoise's door exhausted and drenched in sweat, I was an hour late. I knocked on the door, and it opened immediately. Françoise looked at me completely unimpressed, and then roared with laughter. "You look all done in. Were you in a hurry today?"

AFTER I HAD stammered out a couple of words of apology, I explained to her that my whole life plays out at this pace. I became a journalist because the job suited my restless nature.

"And," Françoise asked, "does that make you happy?"

For a moment, I was speechless. The simple question had caught me unawares. I loved my job, because it always gave me the opportunity to meet

extraordinary people and hear unbelievable stories. But did this lifestyle make me happy?

"I don't know," I said after a while. "Sometimes I have the feeling I'm constantly running after something that I will never manage to catch." Perhaps it was the feeling that as a journalist, when all is said and done, you are always writing about the lives of other people, instead of living your own life. Mostly, I envied how imperturbable Françoise was and how she could create something out of nothing, like that face she had drawn with a few strokes in my notebook.

"You mustn't forget, though," Françoise pointed out to me, "that I have the experience of a very long life. Over seventy years ago, I painted nudes every morning at art school. Every week, a different model stood in front of us, and so I drew fat bodies and thin bodies, large ones and small ones, and I studied every detail of human anatomy. This experience also sharpened my intuition. It's the same for you. You are a writer, and you write every day."

With that observation, Françoise had hit a sore spot. It's true that I did not lack for experience, and in my life I had certainly written many hundreds of thousands of words. Yet with every piece, I had the feeling that I had to start from the beginning all over again. Every word in every article and every sentence in every book was incredibly hard for me. Sometimes I comforted myself with a sentence from Thomas Mann: "A writer is someone for whom writing is more difficult than it is for other people."

"That's absolutely right!" Françoise agreed. "You once told me that I should be happy that I was still alive. You were surprised when I told you that I was tired and would be happy to die. Now you know why. What I do looks so easy, but it costs me an unbelievable effort."

Her confession surprised me. The magic of most works of art certainly rests on the fact that the viewer is unaware of the energy that needs to be summoned to create them. What artist would willingly reveal himself as a plodding production-line worker who must go back over his work ten times before the composition comes together? "I do not seek, I find," Picasso used to say, underscoring the ease of his own genius.

Françoise, conversely, was voicing an open secret: to create a painting or a piece of text sometimes demands a tremendous expenditure of strength, concentration, and labor. I had noticed in my encounters with artists in

different fields that you can't be a weakling if you are going to devote your life to creative endeavors.

When I met the eighty-two-year-old pianist Alfred Brendel, who had officially ended his career a few years earlier, he confided to me that he simply no longer wanted to practice every day. And the novelist Philip Roth let it be  known when he turned eighty that he was now retired. Since then, he has declined every request for an interview with the statement that there is only one thing more beautiful than not having to give interviews anymore, and that is not having to get up every morning and write.

So I was particularly surprised that at the age of ninety Françoise didn't think of giving up and continued to paint every day. Her oeuvre was already vast. She had created about 1,600 paintings and more than 5,000 drawings.

Perhaps, I wondered, she continues precisely because it is arduous work. Because life is only worth living when it is challenging. Someone like Françoise might well have had enough of life only when she has mastered its last challenge.

Françoise shrieked with laughter when I suggested this to her. "You are such a puritan!"

"Well, you are, too!"

"Unfortunately, you are right," she said happily. "Discipline is essential. Without it, even intuition won't help you. And you must practice. Always practice. The Japanese have a wonderful book of the ten thousand things you must draw to really learn how to draw: a small insect, a foot, later a whole person, and finally the sky with clouds. Only when you have drawn all these ten thousand things will you really know how to draw."

I HAD NEVER drawn a foot or even an insect in my life. But the principle was obvious to me: if you know only one thing, you really don't know anything. First you must have drawn everything once to then start over from the beginning and be able to draw correctly for the first time. There's a reason apprentices learn all aspects of their craft before specializing.

And whereas beginners give everything a try when they start and overload their work with ideas, masters of their craft practice omission and simplification. Someone who has seen everything is able to say more with a single line than others can say with a whole series of paintings complete

with curator's notes. Instead of a ballad with a hundred verses, the Japanese master composes a haiku that consists of just seventeen syllables.

The older Françoise grows, the more abstract her paintings become.

But Françoise was wrong when she passed judgment on me and labeled me a puritan. In fact, even as a child, I was undisciplined and easily distracted. As a journalist, I did prove myself to be tenacious in the way I followed up some stories—more to my surprise than to the surprise of those who knew me. However, even after the publication of four more or less successful books, I still found it difficult to write in a focused and routine fashion.

"Aha, but concentration is the alpha and the omega," Françoise replied. "It's no wonder that you find it difficult to write if you are not alone with your thoughts." Then she told me how three-quarters of a century ago, during the occupation of Paris in the war, she had learned how to meditate at a friend's house.

"The first time I went over, she put a small plant on the table and we looked at it without saying a word for an hour. Every week was like that until a year had passed. Then she replaced the plant with a shell, in the third year with a stone, and in the fourth year with a tiny candle."

I tried to imagine how much willpower it took to stare at a plant for hours without saying a word in the middle of occupied Paris and not break down in tears. For four years she had meditated with her friend in this way and had learned to allow all fear, care, and daily hardships to fall away and to give herself over completely to the moment. Where better to practice concentration than in the middle of chaos and destruction?

"The fifth year, Paris was liberated," I said. "Then you surely had other things to do than meditate."

"On the contrary. In the fifth year, we contemplated nothing."

After the years of practice, she no longer needed an object in order to collect herself. Along the way, concentration had become more than a process of self-reflection; it helped her find the core of her subject when she was painting.

Now here we were, seventy years later, sitting in her atelier in Paris. Even in her early years, Françoise had attained a level of maturity that others don't achieve in a lifetime. I looked at the lively artist who sat opposite me, who had punctuated her last statement with an amused smile. She had

understood not only how to live but also how to process her experiences. She had given herself over to reality in order to be able to grasp it and capture it on canvas. The numerous paintings—hanging here on the wall or piled up against it on the floor—were a testament to this achievement.

Through it all, she seems to have enjoyed herself immensely. Suddenly, she leapt up and went to a small bookshelf from which she pulled a volume about Henri Matisse.

"A drawing is a concentrated expression of reality," Françoise explained. "When you concentrate, everything superfluous disappears and what is necessary becomes important. Look at one of Matisse's drawings. It is not particularly detailed. Sometimes it's not even very well executed." She laughed apologetically, as though she needed to excuse Matisse's sloppiness. "But it catches reality better than any passport photograph. That's how Matisse drew the poet Aragon, for example, and it really is Aragon. Everyone recognized him in the drawing immediately, because Matisse didn't just copy him, but he drew his essence. He captured something that was unique to that person. That's what sketching is all about."

I thought again of the woman's head that Françoise had drawn in my notebook. She hadn't divulged to me whether she had been thinking of a particular face (perhaps it was Geneviève yet again?). It didn't seem to me to be the face of just any woman. It had an aura; it had personality. Somewhere in the world there must be a woman who looks just like that or who at one time in her life looked just like that—or perhaps a girl who would look like that one day, for Françoise had not reproduced a face but had, with a few strokes, conjured a being out of nothingness. Today, the sketch hangs on the wall of my study in a simple matte gold frame. When I look at the face of the young woman, I am struck by the narrow curve of her lips. Her gaze is cool but not cold, her features are gentle yet not frail, but with her fine, long nose and long hair she looks more classical, like an ancient Greek, an impression that is amplified by her hair braided into a knot at the back of her neck. No matter how often I look at her, she remains mute and mysterious, yet I have the feeling she would have an answer for any question I might ask her.

Ask yourself how you can capture the essence of another person, those special qualities that belong to them alone, and encapsulate it in just a few

strokes on paper. Matisse could do this, Picasso could do this, and Françoise, it seems, knows the secret as well.

And that was what was so amazing. An old woman sat before me who, if she was in possession of a special kind of knowledge, made no fuss about it at all. Françoise calmly sipped her espresso, the delicious chocolates that I had brought her from Neuhaus to her left, and when I posed prying questions, her response was a heartfelt laugh. I had never come across such a conversational partner in my career as a journalist. She seemed to have an inexhaustible supply of energy, and her answers were disarming. I looked at the paint-smeared palette and the cans of brushes by the easel standing in front of the large window of the atelier, and I decided that I would stop listening like a journalist and start listening like an eager pupil.

"First you must feel something," Françoise explained. "Don't look for someone you don't know unless that person has a particularly amazing face. It's better to choose a friend, male or female, because when you already know someone, you will have drawn them in your mind for a while without even realizing it, for you want to keep their portrait inside you. When you know someone, you are already one step closer to painting this person."

I had never painted anyone in oil, but I still thought I knew about making portraits. After all, it is part of my job as an interviewer to work with a conversational partner until she turns herself inside out and reveals what she is thinking. It is a common misconception that interviews are always about what is said. The manner in which thoughts are expressed and the point in the interview when they are revealed are just as important. Often the most astounding revelations are made only after two or three hours of intense conversation. When I believe I have really understood the person I am talking with, then I can paint their true portrait in words. But interviews are conversations. They are made up of actions and reactions. How much more difficult must it be to capture the essence of a person only by watching them as they model for you in silence.

"Once something very strange happened to me—back in the sixties when I was still doing portraits," said Françoise, as she looked thoughtfully across to the other corner of the atelier, where her easel and painting equipment were standing. "So I had sitting in front of me yet another person whom I had never met before in my life. I didn't know what he did for a living, I knew

nothing about his life—he was a stranger. In the first watercolor that I did of him, he recognized himself immediately: he looked just as he had when he was sixteen years old, and now he was forty!"

"Did you want to flatter him by portraying him as a young man?" I asked.

"Not at all. I simply couldn't do anything else. And you know something else: I painted him over and over again, and in painting after painting, he got older and older until he really did look forty." Françoise laughed contentedly when she saw my quizzical look. "That happened to me a lot. It was as though I needed to see the person in the past before I could draw him in the present."

"Then did you have to paint a whole series of pictures every time before the client was happy?" I asked.

Françoise waved her hand dismissively. "It wasn't quite that bad. When anyone wanted a portrait, I told them: I'll make two drawings, and if you like either one of them, good. If not, then that's all right, too. Then I'll just keep them both. Anyway, I had the impression that I could read the face of a stranger like a book—a book that I had never held in my hand before. So I sat this person down in front of me, and suddenly the book fell open, and it seemed to me as though I could read this person's life in this book: I saw his childhood and youth, the young man, and I saw how he aged, until he looked exactly the way he did sitting before me. In that moment, bam! the book slammed shut and I knew that now I couldn't go any further. I was done."

AS WE HAD been speaking, it had grown dark outside, and Françoise had turned on a light in her atelier. I had been listening to her with increasing intensity, and now it was as though we were caught in the cone of light from the old Art Deco lamp, like figures highlighted in a painting. When she was finished with her story and looked at me, it came rushing out of me. I told her that when I was young, I had had similar experiences. In the tram on the way to school, I usually passed the time studying the people around me as unobtrusively as possible. There was the official with the pinched face who always put his briefcase upright on his lap and held it there firmly with his hands. The old woman in a headscarf and colorful flowered supermarket smock whose complete exhaustion was written all over her face. The Spanish-looking artist with his long hair and skillet-sized black Basque beret.

Contemplating Nothing

I still see them all in front of me, just as I did thirty years ago, and, as Françoise said, I can still paint them from my mental image. But back then, when I looked old women in the face, the picture suddenly changed and I saw them in front of me as young women, shifted fifty or more years back in time. I noticed that some women (strangely it only happened to me with women) have faces that never age. Their physiognomy is formed in childhood by cheekbones and chin and lasts a lifetime. These features—sometimes gentle, sometimes rough—acted as bulwarks against the passage of time. Françoise is such a woman. Her circumflex eyebrows, striking cheekbones, and expressive eyes are the same now as they were in the old black-and-white photographs her father took of her. Other women had faces like ruins, shrunken and spent. It was more difficult to imagine them young, and, given the transitory nature of life, it was a somewhat depressing exercise.

They were strange daydreams that I had back then, triggered by those old women, and I told only a few friends about them, ones I could count on not to say immediately that I must be out of my mind. I had never met anyone else who had had a similar experience. Therefore, I didn't expect my memories to trigger a response from Françoise. But I was wrong.

"There. You see? That is absolutely normal," she responded. "That is a completely normal thing to happen when you get into a stranger's head. Every life has its own trajectory, like an arrow from a bow. When you meet someone, that person is at a particular point in their trajectory, but the way to that point has already been written. Perhaps you sense something even though it is no longer there."

All at once I found the whole subject rather sinister. I had never felt the need to get into strangers' heads. But it is astounding, and has always surprised me as a journalist, how much people voluntarily reveal about themselves when you talk openly with them. And Françoise was right in what she said. If you don't just let people walk by you on a city street without giving them a second glance but really take notice of them, you are stepping over a threshold. Anonymous passersby turn into people you really can read like books. Not that you can understand every sentence or read a person's life-book from the first to the last chapter in the course of a metro journey. Luckily. To know so much about the lives of others would be unbearable, and the first person to be a mind reader would soon commit suicide.

But for Françoise, it was not about thought processes. For her, it was about visible manifestations that seemed to give her a glimpse into people's souls and even into their futures. "It's all got to do with the inner life. The faces of some people change into something more than a mask of skin and bones even at an advanced age. When you observe these people or talk with them, you can feel the whole person. Sit down in a metro station or in a cafe or, my favorite, on a park bench, and draw the people around you. They don't know you, but once you have drawn them, you will know them."

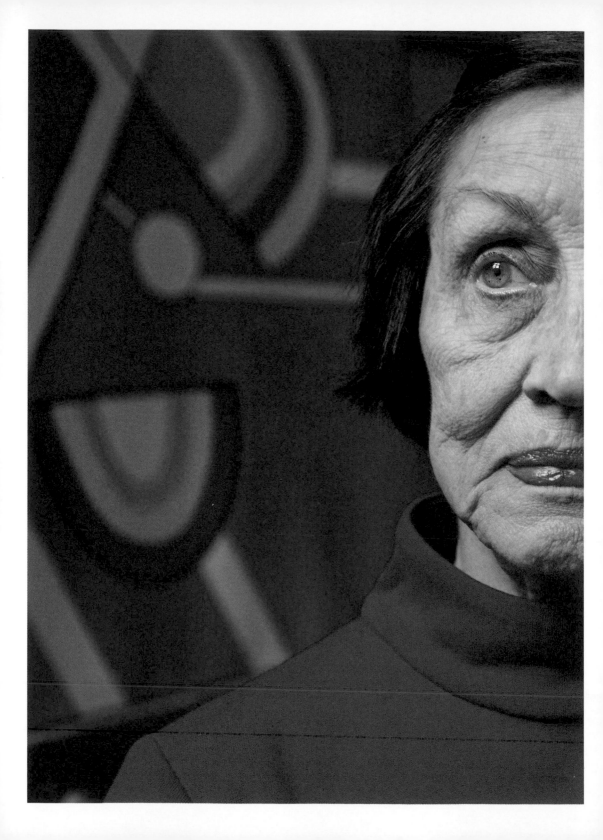

NEW YORK

ABOUT THE PAINTINGS
THE FIFTH LESSON

"WHEN YOU WANT to climb a tree, you choose your own way up," said Françoise, sipping her espresso, "even if you've never done it before in your life." She looked at me as though I were a cat with vertigo. But I was only a writer with writer's block.

"You know, most teachers always want to tell you that this is the way things are. There is only one correct approach, and so you must do it that way. But that's not the case at all. You can approach a subject in any conceivable way if it's the right way for you."

Françoise pointed to a painting on the wall. It was a self-portrait by her lifelong friend Endre Rozsda, with whom she had secretly studied painting in the forties in Paris.

"Endre was my first mentor, but his works are completely different from mine, much more surrealistic and dreamy. Although he was my teacher, he never tried to influence my style."

Three months had passed since our last meeting in Paris, but I had yet to put a single line of the new book to paper. By this time, it was fall, and I had

flown to New York to continue our conversation. I also harbored the secret hope that I could continue my drawing lessons with her without having to show her my barely presentable practice pieces. She was dressed completely in red and, as usual, bright as a button. After we had drunk our coffee, Françoise stood up.

"Drawing is not as different from writing as you think. Wait, I want to show you something special." She raced up the narrow flight of steps at the west end of the atelier into the living space, next to which there was a large storeroom with hundreds of paintings and even more drawings. After a few minutes, she returned with a triumphant smile and put a pile of sketchbooks on the table in front of me.

"I did these more than thirty years ago, when I was still traveling around the world. I almost forgot that I still had them. You know, people always see just my paintings, but they have no idea where the paintings come from."

FRANÇOISE TOOK ONE of the beautifully bound volumes from the pile and opened it. A gondola slid through a lagoon in front of our eyes against the background of a Byzantine dome under cloudy skies. On the opposite page, in sweeping script, stood the words "Clouds, paths, footbridges." There was no doubt—we were in Venice.

But this was no ordinary sketchbook, no cityscapes à la Canaletto, no painter of competent postcard quality here. Françoise did not draw what she saw. She let Venice arise anew from tiny details, which appeared on the cream-colored pages like the memories of a drowned city. Over there stood a single bollard, below it just a few puddles, as though it were not the city that was sinking into the Grand Canal but the other way around. There was a shoreline with a carnival mask lying on it and a gondola on the shore, but in the middle there was an enormous scorpion stinging the background panorama of Venice with its tail. Around the painting, Françoise had painted in sweeping letters bathed in pools of watercolor, "Your gondolas are like scorpions in disguise." And it was these letters more than anything else that let you feel the ebb and flow of the waves that seemed to constantly absorb then disgorge this lagoon city. Then the pale blue, overflowing pools transformed into fishes swimming among the letters and became letters themselves before transforming again into clouds and then into the blue

and green rays of the sun. On the reverse side, bollards danced and the large
S in "Serenissima" ("most serene") became a gondola with the silhouette of
a gondolier standing in it, barely wider than his rudder. Butterflies appeared,
and ladybugs, and finally, two lovers, a man and a woman, happy and despair-
ing at the same time. A woman fell out of a window into the canal, Death in
Venice claiming its victim. And lastly, a naked woman danced on the waves
in front of St. Mark's Campanile. The whole book was a dithyrambic dance
in which pictures and letters blurred together in a unique frenzy. Françoise
kept turning the pages and began to read from the pictures.

"Look: 'Rêve, rêve vague, caressé par les Vagues.' ['A dream, an indistinct
dream, caressed by the waves,' the play on 'vague'/'vagues' unfortunately lost
in translation]. Out of the brackish water of life and the mud of fortune, the
wondrous city has arisen from Venus's clamshell."

Françoise beamed. An irrepressible energy seemed to flow from the small
woman with the severe pageboy haircut and the elegant bright-red dress, yet
she never seemed in danger of losing control over events as they unfolded.
She seemed to me like an ancient magician, precisely aware of what she was
doing with her spells, but unlike me, her amazed apprentice in magic tagging
along in astonishment, she was moving with a sure step along a path she had
followed many times before.

She played with the words, transformed them into new pictures; one
sound faded into another, syllables were mirrored in water and began to
swim in turquoise, blue, and pink until they coalesced into a face.

"Oh Venice, beloved by poets, who would drown themselves in your eyes.
The reflections in the water show your ten thousand faces. And artists loved
you, too, and I don't mean the old ones who were still dreaming of your
mother, Byzantium, but the two Bellinis. The may bugs who sing the pink of
your bricks. The butterflies of the Impressionists drawn by your light and
your little rats."

I was taken aback for a moment, and then I saw there was indeed one
white and one green rat nibbling at the bottom of the page.

I interrupted Françoise: "There's no way the Impressionists felt drawn
by them."

Françoise laughed. "Absolutely not, but in French we sometimes call a
tiny classical ballerina *'petit rat'* or 'little rat.'"

puis
tant d'autres
Turner,
les

papillons
de l'Impressionisme
attirés par
ta lumière

Françoise had drawn a group of young ballet dancers on the other side of the page, calmly practicing their exercises. Rats and ballerinas—I might have guessed Françoise didn't want the Romantics to have Venice all to themselves. To this end, she used the enigmatic and ambiguous qualities of words and embraced the sting in the scorpion's tail.

"But of course there are many rats in Venice." Françoise laughed.

"And it smells," I added, as I remembered the sewer stench in the small back alleys of Venice that had both surprised and fascinated me twenty years ago.

But Françoise had already moved on. She was sitting in a cafe in the lagoon city, thinking of famous lovers who had sealed their fate there. "Happy or despairing, they were all seduced by Venice." For example, Alfred de Musset and George Sand, who, full of love's trials and tribulations, plummeted from a window into a canal right there on the page in front of us. Desdemona appeared in the form of the embroidered handkerchief that inflamed Othello's jealousy, "*La jalousie,* this absinthe-green passion." Never at a loss for a play on words, Françoise had drawn a jalousie in front of a black window (there's a reason it's called a Venetian blind in English).

"The jalousie swallows the restless heart of Othello, the Moor of Venice," Françoise read out loud, pointing as she did to Desdemona's embroidered handkerchief, hung up in the folds of the *M* in "Moor."

I told Françoise that the book looked to me like a forerunner of the graphic novel, a literary form that has been enjoying increasing popularity since the eighties. How amazing that the artist, who was already sixty back then, had immediately tapped into this new format. Matisse also came to mind. I had just seen his jazz series for the first time in a big exhibition in London—those wonderful flowing forms, which the old bedridden Matisse had cut out of card and arranged on large pieces of paper. Alongside them he wrote sentences about art with sweeping strokes.

The sentences are not reproduced in most illustrated art volumes. But they cannot be an accidental byproduct, because Matisse could, after all, have produced them using a typewriter instead of India ink and a paintbrush. And aren't the words in a painting such as *The Thousand and One Nights* from 1950 or the cover he designed for *Verve* magazine in 1943 also integral components of the composition?

"I always wanted to be a painter, but language is also very important to me. Look at these books, and then you will know how I think and work. When I draw, words are never very far away. That's just the way I am." No, Françoise has never been a naïve dreamer, I thought to myself. Intellect is always tucked away in the cracks of her paintings.

Unlike the male princes of painting of her generation, she never showed off. Picasso, Dali, even Marcel Duchamp liked to portray themselves as provocative geniuses. It's no wonder, I thought, that of all the artists of her time, Françoise was most inclined toward Georges Braque and Matisse, whose calm natures most closely resembled her own. Picasso, however, had become her *amour fou,* her obsessive passion, and even with him she had—on the outside at least—always maintained her composure.

The lightheartedness of the Venetian sketches and annotations amazed me. The watercolors and brush strokes made it look as though Françoise had captured the moment of perception on paper. Or perhaps Venice was simply invisible until the artist conjured it up with a couple of swift strokes of her brush? The Venice of our mind's eye, where little rats occasionally crept in at the edges?

Françoise pulled out another sketchbook. This time she had drawn on the perforated pages using nothing but black ink.

"Is that India ink?" I asked.

"Yes. In English it's called 'India ink,' but in French we call it 'Chinese ink.' Apparently, it used to be made from squid ink. Anyway, it works very well for drawing, because it lasts for a long time. Blue ink fades too easily."

The sketches were made on a journey through India that Françoise undertook with her second husband, Jonas Salk. The famous doctor had developed a polio vaccine and was in India on a business trip.

"Wait. I should put my glasses on," said Françoise. "Look at that sari. It's like a spiral. I found spirals everywhere in India. The material is like a cocoon wrapped around a secret."

Once again, Françoise had mirrored the spiral curves of the sari with sinuous letters: "Curves free the poetry of the garment from its slumbering metamorphosis."

She had not drawn a particular sari. She had simply used the curving form of the garment as the seed of an idea.

About the Paintings

"The small format has the advantage that I can draw something like this even in an airplane," said Françoise. "And I drew it all from memory and not from life."

Despite that, the pictures not only represented reality but were also full of detail. She looks at things the way a reporter does, I thought almost enviously. I seldom notice details such as the color of the tie an interviewee is wearing or a person's height, details that could be used later to add color to the text. My memory works mostly in the abstract and superficial.

Françoise, however, grasped the essentials, the baselines, the movements of life in objects and in people. A man was putting on a puppet show and the woman next to him was narrating the story. There was a small vegetable truck. The proprietor was kneeling down in it, offering his goods for sale. On the next page, there was an emaciated man with an expressionless face, whose body was covered with nothing but a sheet.

"Yes," Françoise nodded, "that is a dead man by the side of the road. You see that often over there. In Bombay, the poor sleep in the streets. The only thing they always have with them is a sheet that they wrap themselves up in at night so they can be buried in it if they are dead before morning. I thought of these people as human caterpillars. But instead of hatching, they died in their cocoons."

I looked more closely at the body by the side of the road. Despite his bony shoulders and sunken cheeks, the expression on his face was one of grave beauty. It did not hide his harsh fate and gave him back a dignity that he had never had in life.

EVEN MORE AMAZING was a small book that Françoise had brought back after a journey to Senegal in 1981. The figures in it were highly stylized. Their hands and feet seemed to float freely in the folds of their loose clothing. Their black bodies were not restricted by any lines but only by the surrounding white space of the paper, and I could feel their beauty. Dancers were created using just a few lines, and no photograph could have captured the elegance of their movement more exactly. It was as though Françoise had absorbed their essence in a single glance and preserved it inside herself.

"That is a marabout, an Islamic holy man," Françoise explained. "And that one there is not a holy man but someone selling bread. That there is a

baobab, about the only tree you find in the region. Mostly, they are hollow, and snakes nest in them. But people put their dead in them as well. And those are unusual double nuts. I meant to make a sculpture of them, but then I didn't after all."

Françoise clapped the book shut and put it back on the pile. "There, I just wanted to show you how I activate my memory. All my life, I have made small sketches like those, and I often write words alongside them. So can you see now how you, as an author with your words, are not so much different from a painter?"

I nodded, even though I was envious of the mute expressiveness of the lines in Françoise's sketchbooks. Françoise looked at me happily. Despite her discipline and self-control, I could not imagine her as a strict teacher. Life had made her tough on herself but not on other people.

"You shouldn't expect too much of yourself. Don't begin with an enormous canvas when you are just starting to paint. That's why I showed you the notebooks. They fit into your jacket pocket, and you can always have one with you. When you see something, take out your book and your pen and begin to make magic."

Picasso with his model
Sylvette David (Vallauris, 1954).

SYLVETTE
A CONVERSATION FROM A DIFFERENT POINT OF VIEW

In the book Françoise wrote about her life with Picasso, she described his fascination with one of his famous models, Sylvette David:

DURING THE SPRING *of 1953 Pablo was intrigued by two silhouettes he used to see in an old pottery across from his studio in the Rue du Fournas. They belonged to a girl named Sylvette David and her fiancé, a young Englishman who designed and assembled very unusual chairs, with an iron framework filled out by rope and felt. The chairs were so impractical for sitting in that Pablo was delighted with them. Sylvette's fiancé made one up and brought it to us one evening as a gift. At the end of the arms were two round balls on which to rest one's hands. On the network of rope one could put a pillow and make the chair a little less uncomfortable. It was such an abstraction of the idea of a chair that it reminded Pablo of certain paintings he had done during the 1930s in which Dora Maar is shown sitting in a chair made up of a skeleton framework much like this one, ending in two balls. This resemblance pleased him, and since*

it was obvious that Sylvette and her fiancé were barely doing enough business to get by, he ordered two more chairs like the one they had given him and a third one somewhat smaller. As a result La Galloise was bulging with chairs that were amusing to look at but took up a disproportionate amount of room in view of the fact that no one could sit in them with any pleasure.

After this Pablo decided that Sylvette, with her blond ponytail and long bangs, had very pictorial features and he began to make portraits of her. Undoubtedly he wanted to make portraits of her, but I know, also, he hoped I might think twice about leaving if I realized there was someone else so close at hand who could step into at least one pair of my shoes. But I encouraged him to go on and make more portraits of her, for I found her as charming as he did, and I made it a point never to be around while she was posing for him. The first few portraits he did with enthusiasm, and then he began to drag his heels like a schoolboy doing homework on his vacation. The pleasure was shrinking. One day he reproached me: "You don't seem at all unhappy about it. You should refuse to admit another face into my painting. If you knew how Marie-Thérèse suffered when I began making portraits of Dora Maar and how unhappy Dora was when I went back to painting Marie-Thérèse. But you—you're a monster of indifference."

I told him it wasn't a question of that. For one thing, I had never had the ambition of being "the face" in his painting. Beyond that, the portraits I admired most were some of his Cubist portraits, along with some of Dora Maar, which seemed to me much more profound and inspired than anything he had done of me. I tried to explain to him that it was his work that held me, not the image of myself that I saw in it. What I did see in it, I told him, was him, not me.[1]

A FEW YEARS after I got to know Françoise, chance led me to Sylvette David. The magazine I worked for had asked me if I would interview an eighty-year-old woman who had modeled for Picasso in 1954, when she was a young girl—just around the time when Françoise left him.

According to everything that I had read about Sylvette, she must have been a very different woman from Françoise. The amazing thing about Picasso was that he remained the same person in all the stories and anecdotes. Unless something unexpected turned up, his story had been told.

The women, however, who had crossed his path were all different and all, in their own ways, fascinating. I didn't want to miss the opportunity to find

out how she had experienced Picasso and what influence he had had on her life. I was soon on a flight to Bristol, where I rented a car to drive out into the countryside to see Sylvette.

When I arrived there, a gray sky hung over the storm-tossed county of Devon, but the artist's studio shone with color. A canvas damp with paint was propped up on the easel. The woman with the most famous hair in the history of art had been an artist herself for a long time. Serious young Sylvette David, with a full ponytail hanging down her back, had turned into gentle Lydia Corbett, with narrow braids framing her face. The walls were full of her oil paintings, watercolors, and driftwood that she had gathered from the beach nearby and painted. She rummaged about in a moldy leather suitcase full of old photographs of a breathtakingly beautiful girl. It was no wonder that Picasso wanted to paint her. It was a wonder that he of all people didn't break her heart.

Sylvette David was born into an artistic family in Paris in 1934. Her English mother was an artist, and her French father managed a gallery on the Champs-Élysées. It was her father who suggested Sylvette wear a ponytail after he saw the hairstyle in a theatrical play. The move to the south of France brought the family to Vallauris, where the nineteen-year-old was soon discovered by Picasso. In 1954, she modeled for him for three months. After the end of her first marriage, David found God, moved to England, got baptized with the name Lydia, and, at the age of forty-five, took up painting.

In a few weeks' time, the art museum in Bremen was going to open an exhibition of Picasso's famous series of paintings of Sylvette. Lydia handed me a clay cup with its own lid filled with tea, and we began the interview.

MALTE HERWIG *Lydia, you were nineteen when Picasso asked if he could paint you. He was seventy-three, and his reputation as a philanderer preceded him. Did you ask your mother for permission first?*

LYDIA CORBETT No, I was as free as a bird. My mother had never required me to ask for permission. You know, we were not bourgeois. So I said yes right away.

MH *How did you first meet him?*

LC At that time, I was living with my mother and my fiancé in the village of Vallauris in the south of France, which was famous for its pottery. Friends

of ours had a studio opposite Picasso's house. We teenagers often sat there out on the terrace, drinking coffee, smoking, and entertaining ourselves. One day, a picture appeared over the wall of a girl with a blond ponytail who looked just like me. Picasso was holding the picture over the wall to invite us over. We ran to his house right away. He opened the door and he asked me if I would sit for him. I was completely surprised, because there was a girl in our group who I thought was much more beautiful than I was. She was sexy and self-possessed, but I was the one Picasso asked.

MH *Did he explain why you were the one he wanted to paint?*

LC People whistled after me in the street, because I was very striking. A natural blonde, no makeup, no high heels. But I was actually a very private and shy girl. In my closet, I had a whole lot of gray wool sweaters and men's overcoats that I could hide in. That fascinated Picasso right away. He asked himself: what kind of a strange young girl is this? He was a real gentleman. I had no education and had never studied. He could just as well have said, "What a stupid little thing!" Instead, he worshipped me.

MH *Overnight, Picasso made the ponytail so famous that even Brigitte Bardot, who was an unknown at the time, copied it.*

LC We met once on the promenade at the Cannes Film Festival. She was walking along with her husband, the director Roger Vadim, and she still had dark hair. After I appeared on the cover of *Paris Match,* he gave her a good piece of advice. He suggested she dye her hair blond and wear it up in a ponytail like I did. Then she went to Picasso and asked him to paint her as well. But he had no interest in doing that, because he had already painted me, and superficially we looked very similar right down to the hair. Except that she was very sexy, completely different from me. In comparison with her, I was a very ordinary girl, like Cinderella.

MH *Suddenly, you were as famous as a film star. Did you enjoy the spotlight?*

LC It was horrendous. Journalists stormed our home in Vallauris. I told my mother she should lock the door, and I hid in the bedroom closet. When the newspapers wrote about Picasso's Sylvette paintings, I got hundreds of letters from all over the world from men who wanted to marry me.

MH *Did you answer them?*

LC No, not a single one. My fiancé, Toby, was terribly jealous. I took the letters and ripped them up in front of him. I love men, but they are difficult.

Picasso felt that I was wounded deep down inside. He wondered why I was so quiet and fearful. Once, he painted me without a mouth, because I so seldom spoke. He guessed there was something that I couldn't talk about.

MH *What was that?*

LC My parents separated before I was born, and I missed my father very much. When I was eight, my mother's boyfriend abused me. I told nobody, not even my mother or my husband, and I kept it completely hidden from myself until I was twenty-seven years old. That was the time Toby left me. I was beside myself and thought I couldn't go on living without him. Then I had a vision. There was a crucifix in our apartment that we had bought at a flea market. I felt how my body was suddenly filled with light, and I knelt down before the bleeding Jesus and cried my eyes out. Picasso had felt that years before.

MH *Is that why you once said that Picasso had been the best man in your life?*

LC Yes, he was a surrogate father to me. I had never in my life met another man who was so kind and respectful to me. He opened a door into a new life for me. He was so caring and good to me. He encouraged me and gave me self-confidence and strength. Sometimes he dressed up in a moustache and a red nose like a clown to make me laugh. Once, he painted a spider on the floor and then leapt back in fear when he came back into the room and saw the spider. He could be very silly.

MH *Françoise Gilot had just left him. In her memoir, she suspects that Picasso had wanted to make her jealous by painting you. Did you ever suspect that it was more to him than art?*

LC Young women have a sense for whether men have a hidden agenda. And Picasso knew that I would run away immediately if he did anything indecent. As soon as I appeared at his door, he noticed that I was a very serious person.

MH *Marie-Thérèse Walter, Dora Maar, Françoise Gilot, Jacqueline Roque—they were all painted and seduced by Picasso. Are you telling me that the greatest Casanova in the history of art never once made a pass at you?*

LC Of course he did. Once, he took me to a small room on the first floor that looked like a van Gogh painting. There was nothing in there but a table, a chair, and a bed. Suddenly, Picasso jumped onto the bed and encouraged me to jump onto it as well. Naturally, I refused.

Sylvette

MH *You were young and you needed money. But when Picasso offered you an honorarium, you declined? Why?*

LC I was worried that in return he would demand that I pose for him in the nude. But I didn't want to show him my body. A few days later, I entered his studio and saw standing there a portrait of me naked. Picasso grinned as though we were sharing a secret and said, "I hope you don't mind." Naturally, I knew what he had in mind. He thought I would give in and undress. But I just said: "It's an honor. What a wonderful portrait."

MH *Have you ever regretted not giving in to Picasso's advances?*

LC We never had sex with each other, and that makes it easier, doesn't it? Sex makes everything in life so complicated.

MH *Your sittings were always businesslike then?*

LC We never spoke or drank during a sitting. Nothing! Picasso always just smoked Gitanes. One day, he showed me an enormous pile of empty cigarette packets that he had piled up into a pyramid on the floor, and he said proudly: "Look how much I've smoked." Then he bought American cigarettes and put them on the table next to me so that I could smoke, too, during our sittings.

MH *There's no portrait of you smoking.*

LC Please! He left the cigarettes out, of course. You don't paint people with cigarettes.

MH *What about Picasso's smoking and absinthe drinking in his Blue Period?*

LC That could be, but you don't paint a beautiful woman with a cigarette! Picasso loved beauty. And even at seventy-three, he was a very handsome man. He always smelled of eau de toilette, he was always smooth shaven and deeply tanned, and he had these wonderful black eyes.

MH *Françoise Gilot once described these as "basilisk eyes," because Picasso could kill with a single glance…*

LC I was fine with him looking at me. To be honest, today I do regret that I did not take my clothes off for him. Then there would be a beautiful nude painting of me, right? But there are only the portraits. After the three months, I was allowed to choose one oil painting and one drawing that he had done of me. Unfortunately, I decided on a realistic portrait. Today, I would have chosen a Cubist one. But you have no taste when you are young.

MH *What happened to the painting?*

LC An American doctor bought it in the sixties for ten thousand pounds. Toby and I had very little money then. I cried when I had to sell the picture. The American said that he had no family, and he promised that I would get it back again after he died. Later, he suffered from dementia, and he forgot his promise.

MH *Did you ever see it again?*

LC Yes, six years ago. I got a call from a man in London who had bought my portrait for several million pounds. He invited me and my family to visit him and see it again.

MH *What did you think when you saw your picture again after more than half a century?*

LC I didn't think anything at all. I cried when I saw nineteen-year-old Sylvette, because it reminded me of what had been irrevocably lost.

MH *That's a terrible thought, isn't it?*

LC It's like when someone dies. My mother is dead, my father is dead; they are all gone. And I will be next. The picture is immortal. Nineteen-year-old Sylvette is immortal. Someone said to me recently: "Lydia, you are Picasso's Mona Lisa."

MH *You are the only artist in the history of art to sign all her paintings with two names at the same time: Sylvette David and Lydia Corbett. Why?*

LC When I was thirty-six, I got baptized, and since then I have been called Lydia. But little, innocent Sylvette is still there and is still a part of me. So I like to make self-portraits with both of my faces: Sylvette with her ponytail and Lydia with her braids.

MH *Did you ever see Picasso again?*

LC Just once. In 1965, I visited with my husband and my daughter, Isabel. The writer Pierre Daix was there as well, and Picasso said to him: "Well, the portrait leaves more of an impression than Sylvette."

MH *Sorry, but that is not very polite.*

LC No, but it's true. In 1965, I still looked good, but I was no longer the Sylvette that he had painted. I had matured.

MH *So how long did you keep the famous ponytail?*

LC From 1949 to 1962. After that I wore my hair like Brigitte Bardot.

Sylvette

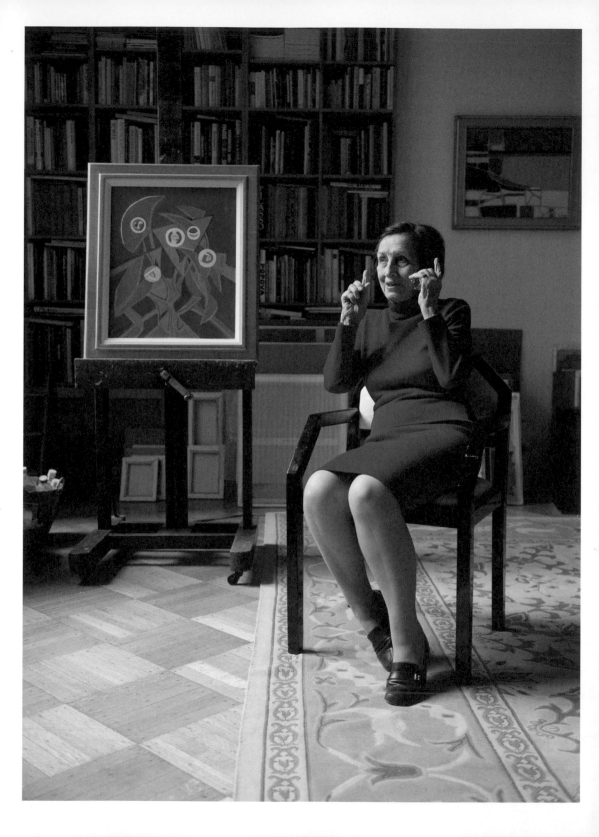

[**15**]

NEW YORK

TWO MUSES

THE NEXT TIME I visited Françoise, spring had arrived in Manhattan. She was busy as usual. Her younger daughter, Aurélia, was visiting to inventory her mother's work. Dozens of paintings were leaning against the walls of the atelier. An abstract painting in blue was on the easel by the large north-facing window. At the other end of the room, next to a hundred-year-old fireplace, was another easel with an even larger painting.

We sat down on the sofa opposite the easel and I told Françoise about my meeting with Sylvette David.

"Ahh." Françoise laughed. "You've been unfaithful!"

Her light green eyes flashed, not with jealousy but full of pleasure and curiosity about the juicy story. After all, it was a half century since she had last seen the nineteen-year-old in Picasso's atelier. Françoise knew the paintings that were the result of those sittings but not the fate of the young girl with whom Picasso had once wanted to make her jealous.

While I described my visit with Sylvette, it became clear to me that the difference between the two women could not have been greater. On the

one hand, Lydia Corbett was gentle and soft, not only in character but also physically. With her narrow braids framing her face and her flowing cotton skirt, she could be favorably compared to a mature flower child. On the other hand, Françoise, despite her delicate frame, was powerful and tough. When she spoke or moved, every particle of her body was charged with energy. She seemed to be absolutely in harmony with the world yet still have it under complete control.

The two women were also dramatically different when it came to their art. Whereas Sylvette found her late calling as an artist decades after meeting Picasso and still seemed to be searching for a direction of her own, Françoise had been clear that she was an artist long before she met the genius.

For more than seventy years, Françoise had worked on her art with precision and discipline, and she had lived her life just as resolutely. She radiated an immense self-control that could not be confused with hardness of heart. She was tolerant of and kind to others. But she could be hard on herself. She had never been afraid of making difficult decisions. My goodness, this woman had left Picasso!

The differences between Françoise and Sylvette had been most apparent to me a few months earlier in Bremen. There I had seen them both together—on paper. The majority of the exhibition in the art museum in Bremen was given over to the innumerable variations in which Picasso, in 1953, had immortalized Sylvette's head with its signature ponytail: on paper and card, in oil, steel, iron, and concrete. No form, no material escaped him after he had found his new model and as he tried to fill the void left by Françoise with tireless acts of creation. He painted Sylvette in a fascinatingly abstract manner as he had once painted Dora Maar or in a realistic style bordering on kitsch as a pretty blonde girl. Under Picasso's hand, the young Sylvette was infinitely malleable. The only thing she wouldn't do for him was undress. Despite that, he had used his imagination to paint her naked.

The pictures he had made of Françoise seemed to me to be completely different. In the second room hung nine studies that Picasso had done of her in the forties. According to his printer, Fernand Mourlot, at that time the painter had fallen into a "lithographic fever" and had drawn different variations of the same head one after the other. Françoise with dark hair, Françoise in silhouette, Françoise as the sun. The pictures resembled each

other in only one feature: the viewer was definitely not looking into the face of a young woman blinded by genius. Instead, the portraits were looking out at the viewer with self-assurance, one eyebrow slightly raised.

This look had so impressed me that I had photographed one of the drawings. I showed it to Françoise, who shrieked in horror.

"That's supposed to be me? What a dreadful picture. He didn't capture me at all."

Her reaction surprised me. I found the picture not only well executed from an artistic point of view, but for me, it was also proof that Françoise had maintained her independence from Picasso, the man and the artist. I took the fact that he had painted her neither charmingly sweet like the young Sylvette nor crying and destructive like Dora Maar as evidence that he had recognized her strong will as an inalienable part of her character. "You get away with just so much," the muse seems to be saying to the painter from the painting, "but if you go too far, then you'll see..."

Perhaps, though, she was simply tired of always looking at herself in the forms Picasso had given her a half century ago. Had she really sold *La Femme-Fleur,* the large portrait Picasso had made of her as a flower, decades ago because she didn't want to see it anymore—or because it hung in her atelier like a curse from the past?

Perhaps it was just that after she left Picasso, the muse dedicated herself to being an artist, and nothing but an artist, once again. She was simply too busy to spend time with old paintings that the most famous artist of the twentieth century had made of her at some time or another. Hadn't she once told Picasso that he was the one she looked for in his pictures, not herself? So it made sense that she no longer needed his pictures now that her interest had turned to other things. She lived in the here and now, and life was a canvas that needed to be revised every day.

That was why Françoise hated devoting her precious time to unimportant things, and after our first visit I knew that the time she devoted to me for all our other visits was taken away from considerably more important things.

This time, I had come in the company of a young photographer who wanted to take a series of portraits of Françoise for my book. Since our first meeting in Paris I had known how reluctant the artist was to have her photograph taken. At that time, she had waved me away when I had asked whether

Two Muses

we might take her photograph for the magazine. She had no interest. It was all a waste of time. There were already enough portraits of her. She had more important things to do than to forgo painting for an afternoon with the camera. And, anyway: "Why do you want to photograph an old face like mine?"

At that moment, I could think of nothing better to say than to tell her how photogenic she was. Only later did I realize that I could not have paid a more redundant compliment to a woman who had had her portrait painted by Picasso and Matisse. Françoise just looked at me with amusement and roared with laughter: "That is the funniest thing a man has ever said to me!"

It took me two years and all my powers of persuasion to convince Françoise that a series of contemporary photographs of her in her atelier would be a beautiful addition to my book about her. "But only if I am in the mood that day, and not longer than half an hour," she had said over the telephone, so I was worried she might change her mind even on the morning of our appointment. To my relief, Françoise was magnificently attired and happily allowed herself to be photographed for two hours while we chatted.

When we were done, Françoise sprang up without the slightest sign of fatigue and took a thick coat out of the wardrobe. "I don't know about you, but I'm hungry. There's a little French restaurant on Sixty-Eighth Street, La Boite en Bois. Come, I invite you to join me."

Runaway Comet, 1998,
oil on canvas, 130 x 162 cm.

NEW YORK

COLOR
AND FORM
THE SIXTH LESSON

WHEN I VISITED Françoise once again at her atelier on Central Park in Manhattan in summer, the porter greeted me like an old acquaintance. Unlike most of his New York colleagues, he was employed not only as a doorman and security person but also as the elevator operator. After he shut the metal accordion-style gate and adjusted the position of the heavy brass operating lever reminiscent of a ship's telegraph, the old elevator moved powerfully into action and we were swept slowly upward.

"And did you try your hand at drawing?" was Françoise's first question after we had sat down in the alcove opposite a still life by Georges Braque. I had, but I was not eager to show her the pathetic results of my efforts.

A FEW WEEKS before, I had been in The Hague to interview Radovan Karadzic, the former leader of the Bosnian Serbs in the Yugoslavian civil war. Karadzic had to appear before an international United Nations tribunal to face accusations of war crimes and genocide. It was the most important war crimes

trial in Europe since Nuremberg, and I had decided to follow the trial for a few days from the spectators' gallery.

According to the strict rules of the tribunal, as journalists we could bring neither recording machines nor cameras with us. Karadzic was defending himself, and I took the opportunity to sketch him in my small notebook when he took the stand, often for hours at a time. This method had an advantage: Françoise had always emphasized that it was a question of speed, and because I wanted to be discreet, I sketched very quickly. A British colleague, with visibly more talent than I, was drawing a portrait of the Serbian leader with skillful strokes when he was escorted from the room by grim-looking UN security officials and questioned about his suspicious activity.

Hesitantly, I took out my small red notebook and showed Françoise the drawing.

"That's not bad at all for a start. What interests me is that you have drawn the hair in a particular way, but you have given his jacket a completely different treatment. Do you see how the white over here looks quite different from the white over there?"

She pointed with her index finger to the subject's hair.

"That is white, but because it is bordered by these lines, it seems whiter than the rest of the paper. The secret of drawing is that it reveals things to us."

I saw what she meant and understood for the first time that with drawing, it isn't only a matter of the lines themselves but also of what you find between them: the emptiness and white space that is left over. Just like when you make a sculpture, it is also about what you leave out and don't do. You have to learn to understand the relationship of color and form and to observe how they develop in tandem. Indeed, observing and thinking are just as critical as doing.

Suddenly, I realized why Françoise could sit for hours in front of her easel without moving a finger, until she stepped up to the canvas and worked in one concentrated burst. She began with an idea, and then observed how it developed when she set to work.

A Cubist painting that appears to have no resemblance to reality can conjure up an idea in the viewer that is more real than what can be seen. We are amazed, because we gaze on the world with fresh eyes and get to glimpse behind its veils and understand its components: the materials, as Françoise

mentioned with her Greeks, out of which the world is made and from which order is created out of chaos.

"That is the marvel that we want to make happen when we draw," said Françoise, nodding encouragingly. "You must learn to recognize what is interesting in what you have done. You mustn't start out by criticizing everything."

She moved her hand in the air as though she wanted to shoo off her shoulder the bird of doubt that so often kept her company. I knew that bird, too, and is there any one of us who can say he's never met him? Doubt is a vigilant bird that lies in wait for every opportunity to dig its sharp claws into your flesh, to stick its beak in your ear and whisper: "No, no, that's no good at all."

Françoise had helped me find something interesting even in my awkward and apparently trivial drawing. It became clear to me that there was more to it than the gentle kindness of a stellar artist. My sense of self-worth was not so underdeveloped that I needed constant encouragement. Or perhaps I was so arrogant that I didn't want any praise at all and wanted to content myself with being my own harshest critic?

"You must sharpen your powers of observation so you can recognize what you have done instinctively. Then you can do it consciously next time. You must drag your unconscious little by little into your conscious mind and work with it. You have no idea what powers you will be able to unleash."

In Françoise's praise also lay a gentle criticism: don't take yourself so seriously, she seemed to be saying, that you believe you alone can decide whether you have succeeded in doing something or not.

"You must learn to listen and see with the unconscious side of your mind. Your life won't always bend itself to your will, either. So search out what is interesting and work with what you find, instead of always subordinating everything to your ego right away."

"But don't all great artists have a huge ego?" I objected. "And Picasso was the biggest egomaniac of all of them!"

"Of course he was." Françoise laughed. "But was that good for him? My philosophy is different anyway. I don't need a huge ego. What I need is a sense of self and that is something completely different."

That's what had fascinated me about Françoise from the beginning, when I read her book about her life with Picasso. It was this absolute insistence on being herself, or rather—as I had come to learn since then—to become

herself. After all, the road to self-realization is long and tiring and beset by surprises and setbacks. There are such things as maps for these journeys. On them social conventions are drawn like rivers, and you could let yourself be swept along in their currents. Educational paths split off: some lead down into dark valleys; others spread out onto the well-populated plains; a few climb up into the mountains, where the peaks are cold and lonely. But everyone has to find the way for him or herself if life is to have meaning.

Once they are grown up, most people assume they've made it as human beings. They stop becoming and believe they are who they are. They think they've known their way for a long time, because they are walking along a well-trodden path. It takes a great deal of courage and strength to be receptive, even as an adult, to the empty space, the untrodden path, the cross-country route.

As soon as we first met in Paris, I felt this incredible self-assuredness in Françoise that had no trace of egotism. It gave her the composure to react to things and to process them, instead of sweeping them aside. But when it came to matters of the core, of the self, Françoise was made of steel.

"To have a sense of self is the most important thing in life," she explained. "If you were to ask me who I am, and if you didn't like the answer, then I would say to you, 'Whatever. Kill me then, but I'm not going to change for anyone! I try to find my own lines.' Whether I succeed or not is entirely my own problem. Sometimes I go this way, then I go off in another direction. But that is never dictated from the outside, but from within. We have a saying in French: *Ça me regarde.* Literally that means: 'That looks at me,' and what it means is 'That is my concern.' You know, I only paint because that is my concern. My paintings are created from shapes and colors that I find in myself and that I want to express outwardly. If people don't like them, it's all the same to me. But they do like them, clearly, so all is good."

I looked at Françoise, whose face gave nothing away, and I had to suppress a laugh, because I was so delighted by the artist's carefree defiance. No one is completely free from pride, but I absolutely believed that she did not paint to woo the approval of gallery owners or the public but to satisfy herself. Criticism seemed to delight her as much as praise.

———————————

FOR EXAMPLE, THERE was the story of John Richardson, the art historian and major critic, who had been knighted by the British queen for his four-volume biography of Picasso and who was regarded as a leader in research about Picasso. When he was a young man in the early fifties, Richardson had got to know Picasso personally in the south of France. When Françoise published her memoir about her life with the painter ten years later, Picasso excommunicated her. The genius raged and forbade all his dealers, friends, and fans, on pain of banishment, from having any contact with Françoise. Only a few, like Alberto Giacometti, dared to ignore Picasso's edict. Certainly not John Richardson.

"Back then, John took every opportunity to attack me and my book, and to deny that it had anything worthwhile to contribute. He didn't even know me." Françoise shrugged indifferently.

"*Bon,* he wasn't the only one. But John did something that few others did. He changed his mind! In the first volume about Picasso, he never even mentioned me. In the second volume, he added a footnote to say that he had changed his opinion of me and that my book was interesting after all. In the third volume, my book was finally not only interesting but also important. So I thought to myself, he has not only changed his mind but also publicly admitted it, and that's the most important thing. I found his behavior so astounding because it is so rare."

Unfortunately, she is right, I thought. Françoise had personally experienced what it means to be outcast by the art world because the most influential and most powerful artist in the world wanted it to be so. From then on, it was not just that the Paris galleries refused to sell her work; one female painter even collected signatures for a petition against her.

"A few months later, she called me and asked for forgiveness. I told her I had no interest in private apologies. But John had the courage to make his change of heart public, and I found that admirable. One day, we met at a vernissage for Picasso at the Museum of Modern Art in New York. John came up to me and asked, 'May I kiss you?' I replied, 'Yes, and I will present you with my other cheek like Christ, and you are Judas, and you can kiss me on both sides.' From that moment on, we were on good terms, because John had finally got to know the real Françoise Gilot. It's better in life to take a second look and try to find out the truth about someone."

Color and Form

She was right. The art world is full of nut cases, con men, and tricksters. It is a fun fair for vain people and self-promoters, for giant egos and sensitive souls. But isn't that what all of life is like? And if we are so ready to deceive ourselves, then how often do other people do so, too?

"I am only interested in people who are searching for the truth," Françoise said firmly. "Most things in life are like a stage set, an illusion behind which hides another and another and so on. The vast majority of people gave up on the search for truth long ago. There are very few who really want to glimpse behind the façade, and it all comes down to those people. Truth is always what is most important to me, even if it is unpleasant."

The longer I listened to her, the more I felt in a strange way that what Françoise was saying was giving me strength. I looked out of the large atelier window and noticed that it had already become dark outside. How long had we spoken? Had it really been four hours? I thanked Françoise for her time and wandered down Central Park West in the direction of midtown, lost in thought.

DAYLIGHT HAD LONG been extinguished by the glow of neon billboards in the streets of Manhattan. The epicenter of this glow was hideous Times Square, the blinding, bubbling, screeching heart of the Big Apple.

Our lives, it seemed, were crammed full of dazzling advertisements, promising us our existence would become meaningful just as soon as we bought a new razor, watched that television show, or ate some fast food. Buy me, click here, gobble me up, the neon signs screamed at me from all sides. A person should buy, buy, buy. Taxis raced past me, musical advertisements flashed in front of me, the smell of fat wafted over from a chain restaurant offering pizzas, and, in the distance, police sirens blared. The kraken tentacle of consumerism was holding the city as firmly in its grip as King Kong had once held the Empire State Building.

Françoise had recognized this: everything was a stage set. One lie that hid another lie, with another lie hiding behind it. The louder it got around me, the more it roared and wheezed, the emptier I felt. What was the point of it all? Leave me in peace, dammit.

My mind wandered back to the drawing lesson with Françoise. What had she said? I should look inside myself for form and color, instead of letting

myself be dazzled by externalities. I looked around once more at the lights of the big city and whispered to them: *Vous ne me regardez pas.* I'm not going to look at you anymore; you are not my concern.

Then I stepped into the middle of Times Square and shut my eyes. I saw two rectangles against a yellow background, one wide and one narrow, and between them the abstract face of a woman. On the narrow rectangle, there was a dark handprint that seemed to understand in the middle of the abstract composition that it was made of flesh and blood. Françoise had shown me the picture a few hours earlier. She had drawn it in 1948, halfway through her relationship with Picasso, and she had given it the title *Ne me touchez pas.*

Don't touch me.

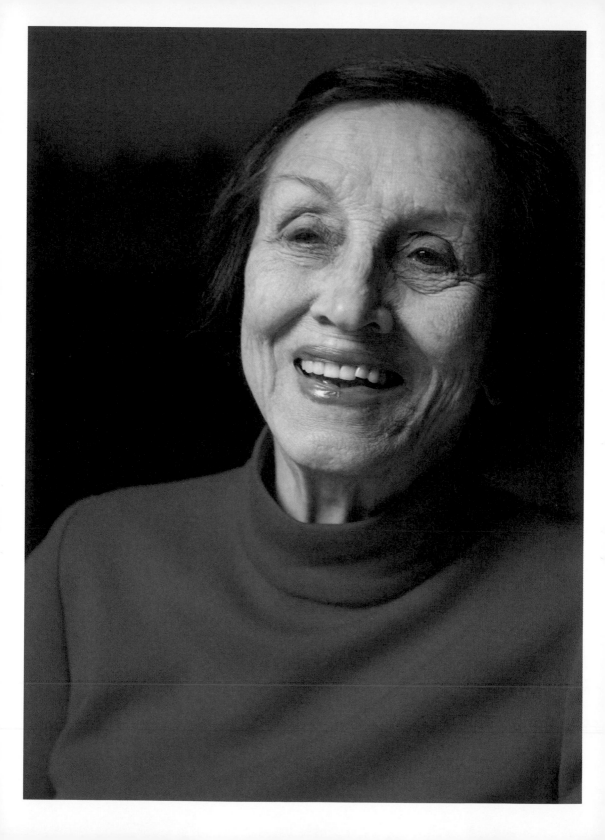

LOVE

"JUST TELL ME what it is!" When I asked Françoise the secret of a happy marriage one day, she laughed and declined to answer. But I wasn't satisfied with such a response.

"Oh well, my marriage to Jonas Salk lasted twenty-five years until his death. So we must have been doing something right."

She reflected for a while.

"We gave each other complete freedom. He went along to his scientific events, and I had my own things to do. So we spent some of our time together and some of our time apart. You mustn't forget that I was already forty-seven years old when I met Jonas. And he was another eight years older than I was. That is not the same as a marriage between young people. But we suited each other very well, and we had a wonderful friendship."

FRANÇOISE MET THE man who was to become her husband on a visit to La Jolla, California, in 1969. Her friend Chantal was married to the American John Hunt, who sat on the board of the Salk Institute, which the doctor and

immunologist Jonas Salk had founded in the early sixties to further develop his groundbreaking invention of the polio vaccine.

The artist knew Salk as a philanthropist who had saved the lives of countless children with his vaccination against childhood paralysis. Her own children Claude and Paloma were among the first children in France to receive the vaccine. The doctor, for his part, was immediately fascinated by this intelligent, sophisticated woman, and he invited her on a tour of his institute. There was only one problem: Françoise understood as little about biology as the immunologist understood about art.

"He was a little bit interested in art, mostly in architecture, but not much really. And because Jonas loved to talk about his own work, I didn't need to speak about mine—it was perfect!"

"How is that perfect?" I asked Françoise in amazement. "After all, art is such an important part of your life and your personality. Didn't you need to talk to your husband about it?"

"Just a moment," Françoise interrupted me. "I had trained for decades with the help of Indian philosophy to lose all my subjective characteristics. My personality as an artist interests me only when I am painting."

She gestured dismissively with her hand. "Apart from then, I am not much interested in myself."

What Françoise had just said astounded me. The artist was a mystery and wanted to remain so, even to a man she loved and who loved her. It was as though there were two different women sitting in front of me. The friendly old woman I got along well with and who didn't come across at all like a dealer in secrets. And the artist who reserved for herself her secret feelings about painting as she dove down into them, alone and beyond everyone's reach. That was the price she paid for her art in order to be able to continue to paint. If the curtain were torn away, the secret would be destroyed. Even Picasso could not break the last seal, which must have annoyed him more than anything else.

"I got to know Picasso very well," Françoise said, and she added with a satisfied laugh, "but he never got to know me, because I hid myself from him. I didn't even know why I had to do that!"

"And with Jonas?" I pushed.

Françoise clapped her hands. "That was so much easier, because he was a practical scientist! So I learned his language, the language of medicine, so

well that we could talk to one another about it. We talked all the time but never about art. Why not? He wouldn't have understood anything about it."

The moment he met her, Jonas Salk knew he wanted to marry Françoise. He visited with her again in the fall, first in New York and two months later in Paris, and they spent Christmas together in France. When she met him in Los Angeles at Easter, Jonas proposed to her. They were married on June 29, 1970, in the town hall at Neuilly in the company of their six children from previous marriages and Françoise's mother.

"You fell head over heels in love as though you were twenty-year-olds, and then married right away," I said in amazement.

"Yes, but the love was more friendship than passion. It was love because I admired his commitment to the human race, his humanity, and he was a fine man. But I can't say I felt passionately about him. With Pablo it was different."

"Didn't you ever miss the passion?"

"I would have missed it if I had never experienced it! But I did, with Pablo, and nothing could ever have come close to this passion. Why should I repeat it less intensely? You should also not forget that both Jonas and I had difficult relationships behind us."

Françoise laughed heartily. "Neither of us was prepared to make more of those journeys up into dizzying heights and back down into the valleys. Instead, we tried to live with each other harmoniously, and that worked very well for us. We spent about half our time together. I worked on my art alone and he on his science. It would have been far too boring if we had hung around each other and shared everything like young people."

Neither had the time for a honeymoon. Françoise moved to La Jolla and right away began to paint again. The American art world, however, didn't interest her very much.

"Why should I meet with any American artists when I had known Matisse, Braque, and Picasso? When you've experienced something like that, you don't want to repeat it on a lower level."

"Does that mean that you really don't like the American art of the last fifty years?"

"I like Jasper Johns a lot, and the works of Jackson Pollock as well, but I have never met him. I reserve the right not to find everyone good. In France, that was the case as well—I didn't like every artist!" She laughed.

Then I asked about Andy Warhol, and for the first time, I saw Françoise look grim. She gave a dismissive wave of her hand.

"Bah, I'm not interested in stuff like that at all. I did know him, but his art is completely devoid of interest for me. Warhol, Rosenquist—this kind of art has too much to do with advertising. As far as I'm concerned, they can do it, but I am completely indifferent to it."

I had never seen Françoise this way. Certainly, she kept her composure as she always did, right down to the tips of her fingers, but she served her contempt on the side, well chilled. She had her reasons.

"What I criticize in contemporary art, above all else," Françoise explained, "is its humor. Art can be many things, but it must not be so witty and funny that we stand in front of it and start going 'Ha, ha, ha.' When I was young, society had a small circle of connoisseurs who knew what they liked and why. Today, people stream into any old gigantic exhibition by the tens of thousands, complete idiots with no understanding of art at all, and then if they find something they can laugh at—something that punches them like a fist in the face—they say, 'How wonderful!'"

I countered that I thought it was a positive development that art was accessible today to more people than a small elite. But I was also uncomfortable with contemporary artists who just wanted to draw attention to themselves. Provocation for the sake of provocation, art as an event. I had been in the thick of things in the late nineties when I lived in England and was one of those who experienced the rise of the Young British Artists around Damien Hirst, Tracey Emin, and Sarah Lucas. In those days, the Royal Academy of Arts in London exhibited soiled mattresses, sharks suspended in formaldehyde, and similar installations. Some of these installations were dull and banal; others I found thoroughly stimulating, even if they lacked craftsmanship.

"We have Marcel Duchamp to thank for that," said Françoise coolly. "He had a very bad influence on American contemporary art. Duchamp was the first to claim that you can be an artist without making art. Today everyone is doing that and completely missing the mark. They should do it my way, but what would that matter to me? I am my own movement."

"But that's the way it's always been," I replied. "Every movement gets old at some point and is replaced by a new one. Matisse cursed Impression-

ism as a newspaper for the soul. And your painting has always developed and changed."

"Of course it has. After all, I'm not the same person I was sixty years ago, or even ten years ago. But I try to evolve the way my inner life prescribes for me and not according to some art propaganda. In a movement, every participant is moving in the same direction. Then somebody says, this is all wrong, and suddenly everyone turns around and goes the other way. I follow my own path. Perhaps that is not the right thing to do, but at least it is a mistake I have chosen for myself. *Voilà!* If I am indeed an artist, then it is because I paint in my own name and not in the name of some movement."

And so Françoise began her own revolution in America. Under the Californian sun, she developed her paintings into colorful abstract compositions carried by the tension between different colors. In the early seventies, she freed herself from the constraints of the rectangular canvas and created her first painting in an oval format. Lotus blossoms grew out of her works, many of which were, not coincidentally, reminiscent of Indian mandalas.

SHE WORKED IN Paris for a total of six months of the year. She spent the rest of her time in her atelier in La Jolla or traveling through the USA. In 1972, she published *Sur la Pierre,* her first volume of poetry, for which she created twelve gorgeously colorful lithographs. Soon, daredevil acrobats were flying through the forms and colors of her paintings. Every year she had more exhibitions of her work.

She still kept her distance from the art world. Instead, the painter in California rubbed shoulders with the leading scientists in the world at that time. At the Salk Institute, she easily overcame the apparent divide between the "two cultures" of biology and art. Two decades after she had looked over the shoulders of Picasso and Matisse during a revolution in art, she was now experiencing firsthand breakthroughs in genetic research and molecular biology.

"I have always been interested in observing things at the moment of their creation. Why should I look at something that is already complete? I want to see people and thoughts working together to create something new. "

I tried to imagine dinners with her husband's colleagues from the institute. As the only artist among scientists, she must have seemed like an incense-swinging altar server among a group of dour cardinals.

Love

Françoise screamed with laughter. "Not at all. I found them much more interesting than all those boring artistic types. We talked of the most recent advances in biology, research into the human genome. Francis Crick, who discovered DNA, visited often. I spoke with these scientists about the latest developments in genetics the way I used to talk with Picasso and his friends about the latest developments in art."

Even today, two decades after Jonas Salk's death, Françoise keeps in contact with his colleagues at the Salk Institute. She told me that recently a researcher had gifted $3 million for a new research chair at the institute and confirmed that the chair would be called after her.

"The Françoise Gilot Research Chair," I asked, surprised, "at a scientific research institute?"

"Yes, just imagine," Françoise said happily. "A chair for microbiology. You must admit, it is a bit eccentric."

I nodded. Françoise took it with her usual mixture of modesty and humor. The idea that a famous professor of biology would be appointed to a chair named after her seemed to amuse her enormously.

"And these things just happen to me. I really can't do anything about them! But then of course I went and gave a small spontaneous thank-you speech. When I read from notes, people get bored to death. I was a thousand miles away in my head, but I concentrated and improvised a few words."

"What did you tell them?" I asked, curious, imagining the faces of all those important people.

"I made them laugh when I said that I felt like a tiny molecule among the huge molecules at the Salk Institute. But anyway, they like me, and they like my work. Every year, I design a poster for the concert at the institute. These scientists understand my work—that is just outrageous."

Françoise looked at me as though she were still astonished that she had turned a group of lab coat–wearing, Nobel Prize–worthy scientists into art lovers.

"Over time, more and more people at the Salk Institute have come to understand my art." She paused for a moment to think. Then she said firmly, "That is the only place where I am understood."

She said this without a trace of self-pity, because she did not feel misunderstood. On the contrary, it seemed to mean a great deal to her that her

work had found a following in the very place where scientists were pushing the frontiers of human knowledge. She felt much more affinity with these people than with the contemporary event artists and their ventriloquist dummies, the gallery owners, art critics, and vernissage visitors chowing down on hors d'oeuvres. The art market had turned into a meat market, the works themselves no more than fast food.

"What would you do," I asked, "if you were eighteen years old again and living in New York?"

"Well, I know I wouldn't become an artist," said Françoise. "Painting today has become a spectacle. First and foremost, you must step on the stage, and then you are immediately more important than your work. But painting is not a spectacle. It is the search for truth in whatever form it manifests itself."

Françoise paused and looked at me calmly. "Sometimes I am sad that I am still alive. I'd rather be dead and finished with painting."

I swallowed hard. She couldn't mean that. But then again, earlier she had said she had had enough of life. But despite her assertion to the contrary, she did not look to me like someone who was tired of living, and I suspected it was painting itself that kept her holding on.

Françoise sensed my doubt and sat up ramrod straight in her chair. "Okay. You're right. I'm not sad, because I still love painting. If I had to begin all over again today, perhaps I would become a writer. But I don't get the same sense of satisfaction from writing as I do from painting. Painting is a sensory experience and it feels so wonderful. When I paint, I am always in a good mood, and I'm in a bad mood when I write."

"That's just the way it is with me," I said, "except I never paint."

"But you are doing what you want to do." Françoise laughed. "And by the way, I feel like the same artist whether I am writing or painting. I believe the words I write on the page are just like my pictures. Anyway, I would certainly not write novels if I were young again today. Philosophy, perhaps."

Certainly, philosophy has been her lifelong passion. She studied philosophy during the Second World War, and she never lost her love of critical thinking. After her bestseller about her life with Picasso, she published other books. The volume *Le regard et son masque (Interface: The Painter and the Mask)*, which she published in the eighties, is a superb essay about painting that

can give the epistemological insights of Kant or Wittgenstein a run for their money.

Not that university art professors would have bothered to give the thoughts of an artist who writes serious study. Undeterred, Françoise continued to work on developing her thoughts in words and pictures. The search for truth never ends, and it is never boring, whatever form it takes.

"Isn't it strange that today I can have much more interesting conversations with young scientists than I can have with young painters?" Françoise asked. "Artists today are all so egocentric. They are absolutely no longer interested in the unknown, only in themselves. For me, art is the relationship with the unknown. I really don't care if I'm interesting in this relationship or not."

While I listened, I was happy that Françoise had not become a philosopher by profession. She could have spent her time giving learned lectures on philosophy to other philosophers, but instead she spent ninety years working on practical wisdom that was far superior to any academic treatise.

Right away, her language would have raised the professors' suspicions, because she spoke simply, directly, and clearly. Like an evangelist, she said "Yes, yes" and "No, no," yet she had retained a feeling for the infinite nuances of the self, which she explored in her paintings.

And so she had reached a state of equilibrium that held her in harmony with the world: small like a molecule in the universe but indestructible because of her agility. She was clever enough to recognize that even elective affinities are not always based on freedom of choice. In the end, the best we can do is take responsibility for ourselves and not for what happens to us.

I remembered the question I had posed to her at the beginning of our conversation today. Her marriage to Jonas Salk had not been a conventional marriage, but it had been a happy one. Does happiness come just at the point when you don't try to force it? At the point when you are happy alone, but when you are also open to trying something new?

Françoise did not hesitate for one moment when she answered. "I have always tried to avoid people rather than let them into my life. Some people believe that I set out to meet Picasso. But that's not how it was. It just happened to me. I did not move myself, I was moved!"

I tried to imagine the scene when Picasso noticed her that May in 1943, as she and her friend Geneviève were sitting with the actor Alain Cuny in the

small restaurant Le Catalan on the left bank of the Seine. The painter was holding court at the next table. Whenever he made a joke or a particularly witty remark, the company at his table laughed. He, however, seemed to have eyes only for Françoise and sent probing, penetrating glances like messengers in her direction. It was as though he was posing for her, she wrote later in her memoir. But Françoise didn't let herself be dazzled. Eventually, Picasso strolled over to the two women, holding a bowl of cherries, and asked Cuny to introduce them.

"Françoise is the intelligent one," Cuny explained, "and Geneviève is the beautiful one." Picasso was not impressed. "You're talking like an actor. How would you characterize the intelligent one?" Their companions agreed that Françoise, in her green turban, looked like a Florentine madonna but a very special one. That seemed to thrill Picasso.

When the two young women explained to Picasso that they were painters, he roared with laughter. "That is the funniest thing I've ever heard. Girls who look like you could never be painters." Now it was Françoise's turn to look unimpressed. She told Picasso that she certainly was a painter and that together with Geneviève she had a show right now in a gallery behind the Place de la Concorde.

"Well—I'm a painter, too," said Picasso. "You must come to my atelier and look at some of my paintings."

The rest is, as they say, history. Françoise had not taken the initiative, but she had played along.

"That's how it always goes with me." Françoise laughed. "And that's how it was when I met Jonas. People throw themselves at me, and up to a certain point I can say no or yes. But people always think I'm this incredibly ambitious person who wants to achieve this or that. But I don't want to achieve anything other than my painting. Everything happened to me, and that is something else entirely. Perhaps it all happened to me precisely because I didn't want it."

What Françoise was saying seemed, at first glance, to be a recipe for lifelong unhappiness, the curse of Job: the feeling not only of handing yourself over to fate but the opposite of experiencing what you wanted to experience. Even the ancient Stoics, masters at stifling joy in life, would have found this a difficult way to be happy—or would they? Françoise didn't say anything. She

just looked at me. Although she always had an answer at the ready, she didn't want our conversation to become a ping-pong game where I hit a question over to her side of the net and she lobbed back a reply. I took advantage of the pause to think again about what she had said.

Despite great misfortune, Françoise had dedicated her long, event-filled life to the thing that mattered most to her: painting. Along the way, she had accepted only what could not be avoided, and wasn't it better to use her energy in a positive direction, instead of wearing herself out fighting against the inevitable? There she was with her ancient Greeks again, with the Roman philosopher Seneca, who wrote more than two thousand years ago: "Happy are those who are content with their lot in life, whatever it might be, and who are grateful for what they have."

Suddenly, I realized why Françoise's words seemed to me so much more persuasive than things I had learned in school or gleaned from self-help advice. Françoise spoke with the wisdom of what she herself had lived, a wisdom connected to insights that went back thousands of years, authenticated with the seal of her own experience.

"I have always tried to travel through life as unencumbered as possible. Without heavy baggage and without many relationships. When you do that, your steps are lighter and you can move forward. That is why I banished many things from my life, and what was left, that was what was unavoidable and had to be that way. Then I said yes."

Françoise looked at me, and I could feel that she was thinking of our first meeting. "I could also have said no to you that first time you called. My intuition told me that I should open the door to you. But you were the one who asked."

"I hope you have not regretted that decision." I sighed, half in jest.

"No. I find it interesting to talk to you. That is where you have to make a decision in life. Either you are alone and that is good, or you look for someone to talk to who can open up new directions for you."

Perhaps that was the secret of her happiness. Perhaps she had found in Jonas Salk someone to talk to who opened up new directions for her. He might have fallen head over heels in love with her, but the fascination seems to be have been mutual.

Shortly after they first met in 1969, Françoise painted a gouache of a young girl looking at a young boy with an expression of amused curiosity. The different skin colors of the young pair make it clear to the viewer that the two come from different planets. Above his head float organic shapes; behind hers shine geometric rays. Neither one looks the other in the eye, but the picture glows with a mysterious sense of intimacy. It is a declaration of love.

141

The title is *Magic Spells*.

With Jonas Salk in 1973.

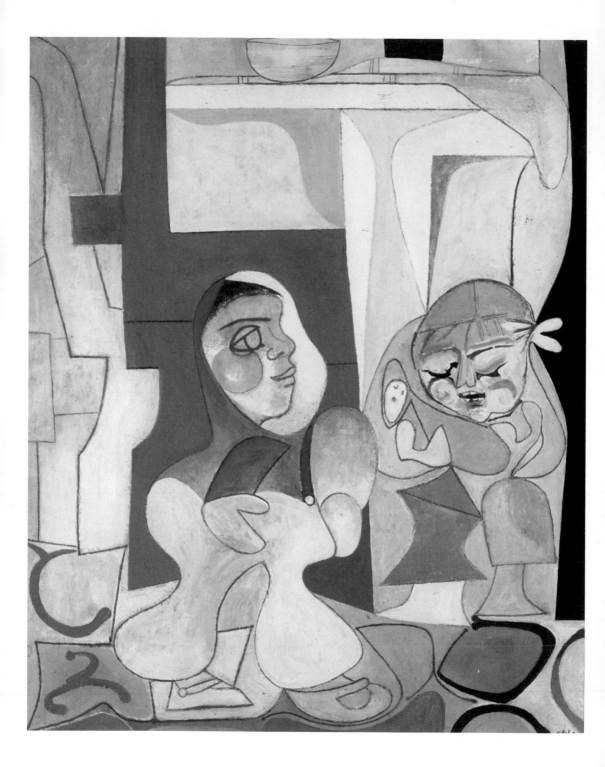

CHILDREN, COOKING, ART

"ACTUALLY, I NEVER did want to have children," said Françoise, waving off the idea. "I didn't have the personality for pregnancy at all."

Yet another very intimate question, I realized, but I did not want to settle for the idea that the woman and the painter were two different people. The strict division between life and work is a hobbyhorse trotted out by many who are sticklers for academic approaches, but in my interactions with artists, it's been clear to me that it is impossible to draw a line that clearly separates the two spheres. Apart from that, I was curious how she had managed not only to raise three children alone but also to leave behind such an impressive body of work.

Françoise talked readily and at length about art and philosophy, and also about her own work, but whenever I brought the conversation around to topics such as love or happiness, her answers became brief and brusque. *Bon!*

It wasn't that she wrapped herself in silence and forbade me to pry into her private affairs, but in those conversations she came across as someone who didn't expect to be understood by other people. When she talked about passion, love, and happiness, Françoise became a mathematician of emotion.

< *My Children in the Kitchen*, 1950,
casein and oil on wood, 100 x 81 cm.

She explained, coolly and clearly, how things were for her. Her words held no trace of regret but no sentimentality either.

She had been in a relationship with Picasso for more than two years, but Françoise had not yet given in to his demand that she move in with him.

"I didn't want to move in and share his life with him. I wanted to have my own life and see him when we had both finished our work. I wanted to have an affair, if you like, but nothing more."

Picasso's relationship with Françoise did not stop him from going after other women. The young woman managed this with the maxim: "What I don't know about won't hurt me."

"Truth be told, I found it all a bit absurd. After all, I was twenty-three and he was sixty-three, but he wanted to have affairs. I'm not particularly pretty, it's true, but there were always a lot of men hanging around me. I was the one who should have been having affairs, not him!"

"Did you tell him that?" I asked, anticipating a colorful description of one of Picasso's artistic rages.

"No, I didn't." Françoise waved the idea away. "There was no need to provoke the bull, as it were." She laughed heartily. "Waving a red flag in front of him was enough to do that. You didn't need to add ridicule as well."

Even though she knew it was a mistake, Françoise eventually gave in to Picasso's persistence and moved in with him. Soon, the artist was insisting she should bear him a child. In this way, he hoped to bind her to him even more strongly. Françoise agreed.

"From the outside I looked like a woman, but deep inside I felt like a boy and I hated being pregnant."

She had two children. Claude was born in 1947, and in 1949 along came Paloma, her first daughter. Usually, Picasso left Françoise to her own devices when she was pregnant, confident the child she was carrying would keep her occupied. She described her pregnancy with Paloma in her book on life with Picasso:

WHEN I WAS PREGNANT *with Paloma, Pablo traveled to a meeting in Warsaw. He wanted to be there for just a couple of days and promised to write to me every day. Instead, he had his driver compose the telegrams and he was away for four weeks. When he came back, he asked me, with a big grin on his face, whether I*

was happy that he was back. I slapped him around the ear. At least this one time I was a goddess. From then on, whenever he was away, he wrote to me every day.

The months leading up to the birth of our second child were, in many ways, a lot less burdensome for me than those that preceded Claude's. While I was carrying Claude, the idea of having a child was a great worry to me and I was painfully wrought up. But this time I had quite accepted the idea of having another child, and the obstetrician I had acquired only a week before Claude was born, I had now throughout my pregnancy. Then, too, during the first pregnancy I knew almost no one in Pablo's entourage well, but in the interim I had made my own corner in his world and things seemed much less black as a result.

Physically, though, I had begun to feel weaker. Pablo and I always went to bed very late and since I was working hard at my painting all that winter and getting up early in the morning with Claude, I was very tired. When I slept, I didn't rest well. Claude was nearly two years old and wouldn't stay in his carriage. Sometimes I would walk him in a pair of reins but that wasn't ideal, either, so as a rule when I set out into the Rue des Grands-Augustins I used to carry him in my arms, and that may not have been a very good idea. About two months before the second baby was expected, the doctor told me he was concerned about my condition. When I went to see him a month later, he examined me and told me to come back again in three days. That time he looked me over and told me to go home, get my things together, and leave for the clinic at once.

SINCE IT WAS the day of the opening of the Peace Congress at the Salle Pleyel—April 19, 1949—and Pablo, as one of the prize exhibits, was quite taken up with that, I objected, a little feebly, and asked the doctor if it was really necessary. He assured me it was. "I'm going to give you injections to get this over with," he said. I told him it wasn't very convenient and that Pablo had a lot to do. "I don't care about that," he said. "That's the way it's going to be, so let's not waste time talking about it."

I went home and told Pablo what the doctor had said. I asked him if Marcel could drive me to the clinic. He looked annoyed.

"I need Marcel today," he said. "You know I have to go to the Peace Congress. Besides, I've got to pick up Paul Robeson." I told him I realized it was inconvenient for him but it was inconvenient for me, too.

"Well," he said, "if you need a car, you'll have to find another solution. Why don't you call an ambulance?"

Children, Cooking, Art

Marcel, who was sitting over against the wall reading his newspaper, looked up. "We could drive her around to the clinic on the way to the Congress, couldn't we?" he asked Pablo. They discussed it with the thoroughness due a major tactical decision. Finally Pablo shrugged. "You drive me there first," he said, "and then come back for her. I don't want to be late." Three days before that, he had been having labor pains for me; now, apparently, he had transferred his anxiety to the Congress.

When I reached the clinic it was nearly five o'clock. The doctor was waiting because I had been expected at two. Toward eight that evening, the baby—a girl—was born. Pablo had been calling from time to time from the Salle Pleyel to inquire about my progress. He had lost his anxiety over the Congress and shifted into the role of nervous father-to-be. His famous dove was plastered all over Paris on posters advertising the opening of the Peace Congress and when he heard he had a daughter he decided she should be named Paloma. He rushed to the clinic for a quick look at his new dove. He found her "lovely," "beautiful," "marvelous" and all the other words excited fathers fall back on. He was most apologetic for his "preoccupation" earlier in the day.

The next morning I heard people arguing outside in the corridor. I had a feeling they must be journalists trying to force their way in. I called the office. The supervisor arrived just as they were about to break into my room. They had reached my corridor after giving false names and pretending they were there as visitors. Just outside my room they were headed off by a nurse, whom they tried to bribe to let them take pictures of Paloma. The nurse told me they offered her a hundred thousand francs to bring Paloma out. When she refused, they were ready to burst in and take what photographs they could. At that point the supervisor arrived and ordered them away.[1]

When children are born into a family of artists, they get to be models very early on. Mother Françoise and Father Pablo drew Claude and Paloma often. Particularly Picasso, who created whole series of drawings of the children.

I find Françoise's drawings of Paloma sleeping in her cot or the two children in the kitchen more intimate. It is as though their mother had tried to harmonize her artistic challenges with the children's personalities, instead of subordinating their personalities to the artist's desire to experiment, as Picasso always did with his models.

Although these muse-children gave Françoise's painting a new momentum, she soon felt as though she were in jail. It's no accident that we see her in the 1952 painting entitled *Liberté* sitting by the children with a pensive look on her face, while Claude writes the value-laden word *"liberté"* on a blackboard.

In 1952, Françoise had her first solo exhibition in the Paris gallery of Louise Leiris. Among the pictures displayed at this show was a series with the kitchen, of all things, as a leitmotif. I asked Françoise why she had made use of the calculated cliché of the housewife who paints.

"But just take a look at that kitchen!" said Françoise, pointing with her finger to one of the pictures. "The window here is barred and looks like a jail cell. Or perhaps you know of a kitchen with bars on the windows? I allowed myself a bit of black humor."

Now I wanted to know just what was going on. "Did he banish you to the kitchen then?"

"No. And that was Pablo's good fortune, because I can't cook anything at all. We had a cook, and she looked after the children as well. As I was an only child, I had no idea how to handle children. I made the pictures of the kitchen because I wanted to paint something about everyday life and not something beautiful but boring like flowers."

The more controlling and unpredictable Picasso became, the more Françoise entertained the thought of leaving him. But she waited, partly for the sake of the children, as Picasso tried to turn her into a broody hen.

"Pablo wanted me to be pregnant all the time, because then I was weaker and not quite myself. So after the second child, I said enough was enough. Because I no longer wanted to be pregnant, Picasso made this sculpture of a pregnant woman. I didn't like the sculpture very much at the time, and when I told him so, he hacked her feet off."

"Why did he do that?" I already had a bad feeling about this. Like a voodoo priest, Picasso wanted to cripple his beloved so that she could never leave him. I thought about the horrific tradition of foot binding in ancient China, when young girls had their toes broken and their feet tightly bound so that they could only hobble around and never leave their homes.

Françoise nodded. She had warned him as she became sadder every day that their love was slowly dying.

Children, Cooking, Art

"I told him, 'I'm here because I love you. But if one day I no longer love you, no power in the world will keep me here, because I can walk on my own two feet.'"

"And that was when he hacked the feet off the sculpture in a fit of rage?" I asked Françoise, as I felt anger rising within me. Anger at the self-righteousness of the husband and father Picasso, anger at his counterfeit charm, his brutality, his cruel mind games.

When I looked up, I noticed with astonishment that Françoise was not angry or sad at all. In fact, she was smiling gently. "He had cut off my feet, but I could still leave because it was only a sculpture!"

That's the thing about conjuring tricks. Even a genius like Picasso is brought back to earth from time to time by the force of gravity—or by the willpower of a strong woman. In 1953, Françoise did in fact leave him. His plan to bind her more strongly to him through the children had failed.

"I didn't want to have any children, but when I had them, I loved them so much that I loved Picasso increasingly less. Pablo had not expected that. You know, that is the secret of having children—for a woman at least. As soon as the darling tiny things are there, you don't want to do anything but care for them. But for practical things like diapers and cradles I had no talent at all. I left those to the nurse."

"Did Picasso help look after Claude and Paloma while you were still with him?"

Françoise clapped her hands together over her head in a gesture of horror.

"That would have been a disaster. Think of his oldest son, poor Paulo, who never had a proper upbringing. That was another reason I took the children with me to Paris after the separation and made sure that they were enrolled in a good school. Then their father saw them only in the vacations, in summer, or at Christmas."

AFTER THE BREAK with Picasso, Françoise married the painter Luc Simon in 1955 and had a daughter with him—Aurélia. After a decade with Picasso, she was now living with a painter of her own generation from her own country.

Simon was two years younger than Françoise and came from an old artistic family whose ancestors had created the stained-glass windows in Reims Cathedral in the thirteenth century. The stress of carrying on the family's

artistic tradition didn't make it any easier for the painter to find his own style. After a year, Françoise knew that the marriage would fail. Despite this, she stayed with him for another six years.

"I should never have married Luc." Françoise sighed. "That was my mistake. He liked me very much, but physically I was not his type. He was my type, but that was not enough. Apart from that, he suffered from severe depression, and it was hard on him that I was better known as an artist than he was."

"It's often the other way round," I interjected, and I mentioned a statistic I had found, which said there was not a single work by a woman among the ten most expensive paintings made by post–Second World War artists. The auction prices for works by male artists were about ten times higher, and works by female artists came under the hammer far less frequently at prestigious auctions.

At the last auction at Sotheby's in New York, the ratio was eleven to one. The most expensive postwar painting, *Orange, Red, Yellow* by Mark Rothko, sold for $86.9 million; the most expensive piece of art by a woman, Louise Bourgeois, fetched only $10.7 million.

"Why is it that female artists often stand in the shadow of domineering men?" I asked Françoise. "Surely not because they are kept busy having children?"

"It's true that women get less for their art than men," Françoise replied, unperturbed by my provocation. "Even today, many more male artists are exhibited than female artists. But to a certain extent, as women that is our own fault. As a woman of course I know all the weaknesses of women. For example, they are very narcissistic. Much more so than men, don't you agree?"

"I see it somewhat differently," I countered. "Picasso, for example, was an enormously narcissistic man."

"Okay, but he had his feminine side. Anyway, feminine narcissism is often directed outward to physical appearances, and that is a very limited view."

"But men can be very proud as well," I said, amazed by how harshly Françoise judged her own sex. She had never had grounds to be envious of other women. But she had evidently seen too many of her contemporaries fail in their bid for emancipation, give up, and slip into a comfortable life conforming to conventional gender roles—women who said no when they

were twenty and yes when they were thirty-five, because they had lost their courage. Françoise always said no, because she felt that was the right thing to do. And she was still doing it at the age of ninety.

It is not a question of generation but of personal courage. Even in the twenty-first century, feminism, for most women, is an attitude that doesn't cost much when they are young but extracts an ever-higher price as they age. The world may have become better for women, but it's still a long way from being fair.

"You could say," said Françoise, "that in my life I have plucked up the courage to cross boundaries and to refuse to accept a situation if I didn't want to accept it. But many women don't have the courage to cross boundaries. No one has ever encouraged them to become themselves."

There was no criticism in her voice, rather compassion. She was her own movement. What other women decided to do with their lives was nothing to do with her. But she had seen a lot.

"Take, for example, a family with three children, two of whom are girls. From the beginning, less is expected from the two girls than from the one boy. So the girls make themselves small. I saw this with a whole series of young Chinese women I knew who did not realize their potential."

In this respect, Françoise had been lucky. She was an only child, and after the carnage of the First World War, the family consisted almost entirely of women. So she was raised as though she were a boy, and she was allowed to ride and ski and swim.

"That helped me develop my self-confidence and to have no fear. I was never susceptible to an emotion like fear. When I was thirteen years old, I stood on a high balcony and someone called up that I should jump. And so I jumped, and broke my foot. But I jumped. When someone provokes me, I react: full steam ahead! My parents always wanted a son. Instead, they got me. And so I had to develop my body and my mind as though I were a boy. I didn't play with dolls but with swords."

Françoise laughed conspiratorially. "Of course, my parents regretted it later, because I wasn't afraid of them anymore. They hadn't expected that. But the upshot was that I was raised very differently from other girls of my generation. They all thought, you can't do this, you can't do that. But that is nonsense. Of course you can!"

I asked myself what kind of a mother Françoise had been after an upbringing like that. Had she brought up her own children using the same template? And did that work?

Françoise was highly amused by my question. "Ask them what they think! But start with my two daughters, they are the more reasonable ones. Claude is often in a bad mood. He's just like his father." Françoise laughed, while I conjured up a picture of a raging Picasso in my mind's eye.

As the administrator of his father's estate, Claude jetted back and forth between New York, Gstaad, and Paris, while making sure the costly renovations at the Picasso Museum in Paris were completed after years of setbacks.

So I started with the daughters and sent Paloma a fax. She wrote back right away saying she was in Morocco, but she would be happy to help and we could talk on the telephone. Paloma Picasso had a career with Tiffany as a jewelry designer, and I caught up with her by telephone in Marrakesh.

"When I was thirteen years old, and the French women's movement was in full swing," she told me, "I had absolutely no idea what they wanted. After all, I already had all the freedoms that the other women had to fight to get for themselves. Thanks to my mother, we were far ahead of our time."

I had to ask myself whether the price of freedom had perhaps been a lack of maternal care and attention. In an interview with *Vogue* magazine, Françoise had once said that she didn't think it was a good thing when parents and children are too intimate with one another. That could easily turn into a jail. She followed the same philosophy in her marriages.

"That's right," Paloma said. "My mother never coddled us. I think that made life more thrilling, because she didn't constrain us. She was a very liberal woman, and she gave us the feeling that we were responsible for ourselves. She never spoke to us as though we were tiny children. Sometimes it was a bit too much. Once, I asked her a simple question about my schoolwork, and she started right in with the ancient Greeks and told me way more than I needed to know. But she always gave us advice when she thought it was necessary—mostly in such a subtle way that we didn't even notice."

There are many different ways of bringing up children and tricks of parenthood, but as I began to realize while I was talking with Paloma, Françoise had a particularly unusual way of giving her children advice and support.

Children, Cooking, Art

"She is a good fortune-teller." Paloma laughed. "She has a way with words. So she often sat us down to a tarot card reading and hid her parenting advice in her fortune-telling."

On my latest visit with Françoise in New York, her younger daughter, Aurélia, was with her in her atelier. Aurélia had studied architecture at university, and she also looked after her mother's archive. She had just compiled a huge catalog of her mother's drawings and paintings over the last three decades. Apart from that, her main task was to rein in her mother when she started carrying her large-format oil paintings around her atelier as though she were half her age. "No, no, *pas de problème*," Françoise would say and put on her innocent face when Aurélia had to tell her off.

AFTER WE HAD chatted in the atelier for a couple of hours, it was noon, and I wanted to take my leave.

"But I'm hungry," Françoise called out. "Let's all go out and eat together." Without waiting for an answer, she threw on a gray winter coat, tied a bright red scarf around her neck, and grabbed her purse. "*Bon?*"

Françoise led us to the tiny French restaurant La Boite en Bois, just a few streets away on the Upper West Side. The owner greeted her effusively and led us to a small table right away. She ordered foie gras and a huge plate of mussels.

While we feasted, Aurélia suddenly noticed a thin line of blood running down from Françoise's nose. Shocked, she jumped up and offered her mother a tissue. Françoise didn't allow the incident to phase her one little bit. She tore a couple of strips off the paper tissue, inserted them into her nose, and continued to eat as though nothing had happened.

I remembered one of the old lessons my parents hammered into me when I was still young and wild: if someone has a mishap in public, don't make a fuss about it; that just makes the situation more awkward for that person.

While Aurélia and I fussed, she calmly waved us off. "This happened to me once at an art critics' dinner. People got terribly worked up, because they thought I had had a heart attack. I said, 'No, I just get nosebleeds from time to time!'"

Françoise accepted the situation—as she accepted everything—with admirable composure. For almost another two hours, we sat in the small restaurant talking about art and life.

At one point, Françoise alluded to herself as a sphinx without a secret, referring to the title of a short story by Oscar Wilde.

After I had said my goodbyes and walked back through the streets of Manhattan to my hotel in midtown, I thought to myself, I know about sphinxes with secrets, but a sphinx without a secret is something new to me.

The old lady whose voice had sounded so impossibly young that first time I telephoned didn't see it as her job to surrender her secrets to the world. A sphinx's riddle can be solved, and when it is solved, then it is also over and done with. Françoise, however, wanted to remain in a lifelong state of constant motion, and her zest for life had ripped me out of the inertia of the everyday. Everyone must find his or her own path through life. Françoise had not given me an answer, but she had pointed me toward questions I had never asked myself before. She had shown me that I could travel my path more confidently, even if I didn't know where it was leading me.

I looked up, and even though I had often been in New York, I noticed something for the first time amidst the glaring, roaring flash of this metropolis of glass and steel—a bird. I looked at it for a while and tried to attune myself to its movements. Then it flew off, circling over the yellow taxis and the people on the street, soaring out of sight.

It was a moment before the sounds of the city washed over me again like a wave. It seemed to me as though, just for a short while, I had been breathing underwater. How rare and precious are such moments if you only live on the mundane side of life, if you only choose the way of least resistance and aspire to no higher goal than material comfort.

"If you want to really live, you must risk living on the edge, otherwise life isn't worth it," Françoise had said. "When you open yourself to risk, you will also experience bad things, but mostly you will learn a lot and live and understand more and more. Most importantly, you will not be bored. The very worst thing is to be bored."

That was no riddle. The answer was simple: choose the cross-country route. Off you go!

Children, Cooking, Art

Paloma Picasso, Aurélia Engel,
Françoise Gilot, and Claude
Picasso. In the background,
the painting *Night Sky* (1999).